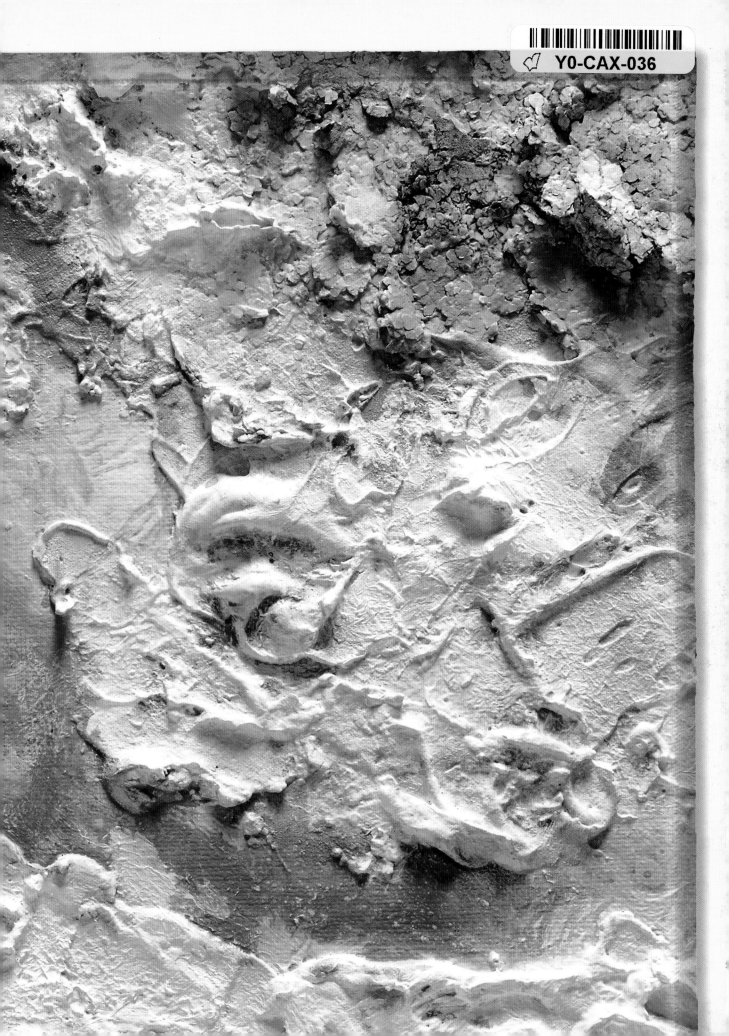

Painting Recipes

Textures

Oils—Acrylics

Painting **Recipes**

Textures

Oils—Acrylics

We present the following

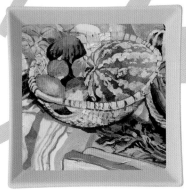
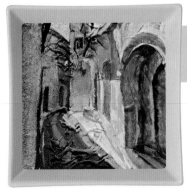
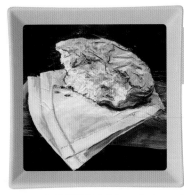
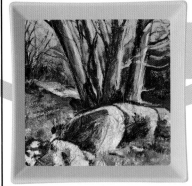
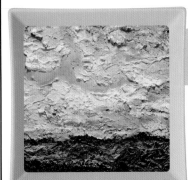

Recipes

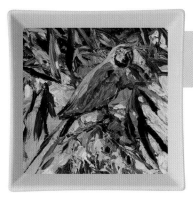
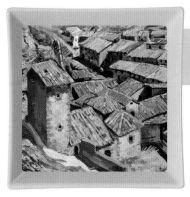

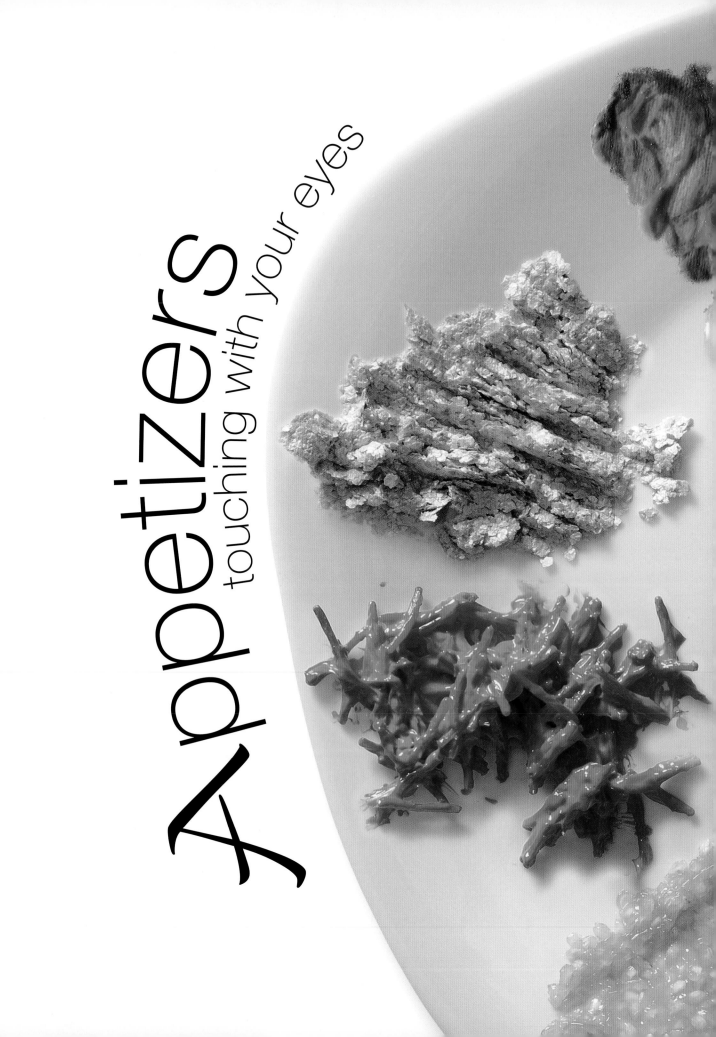

Appetizers
touching with your eyes

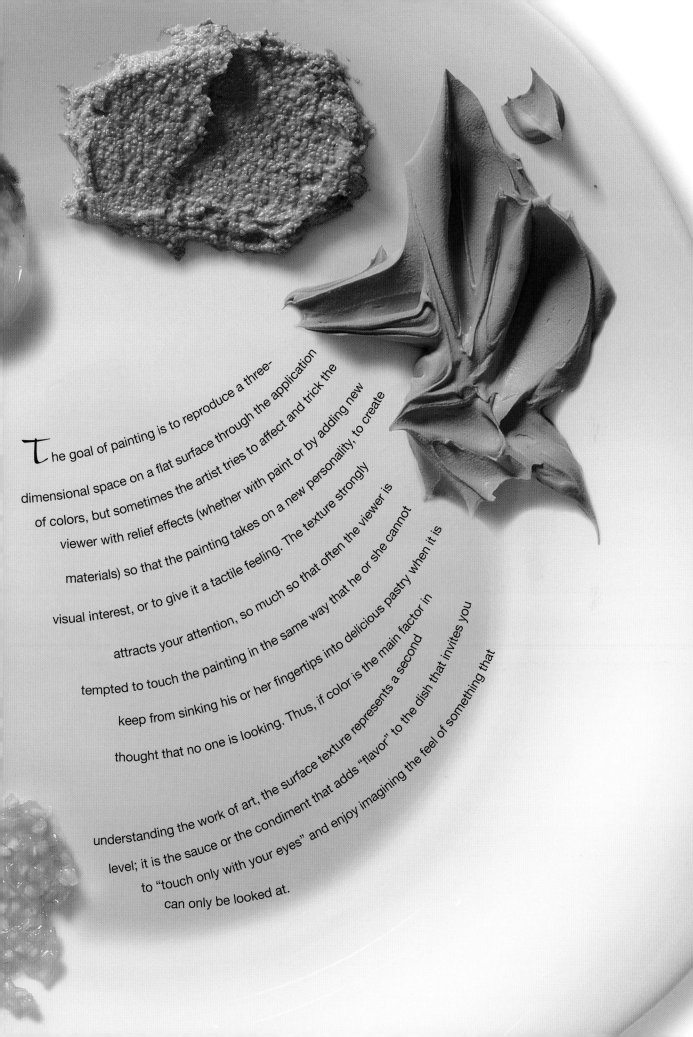

The goal of painting is to reproduce a three-dimensional space on a flat surface through the application of colors, but sometimes the artist tries to affect and trick the viewer with relief effects (whether with paint or by adding new materials) so that the painting takes on a new personality, to create visual interest, or to give it a tactile feeling. The texture strongly attracts your attention, so much so that often the viewer is tempted to touch the painting in the same way that he or she cannot keep from sinking his or her fingertips into delicious pastry when it is thought that no one is looking. Thus, if color is the main factor in understanding the work of art, the surface texture represents a second level; it is the sauce or the condiment that adds "flavor" to the dish that invites you to "touch only with your eyes" and enjoy imagining the feel of something that can only be looked at.

Materials and Techniques for Textures

The approach to creating textures in a painting consists of incorporating substances during the process of making the picture that modify the consistency of the paint, or adding solids that adhere or mix with it. In the following pages we will attempt to explain the main ways of composing the surface of a painting with texture: by adding fabric and crumpled paper, adding fillers, adding more volume with gels and mediums, and incorporating modeling paste. These are the most basic and common ways of creating texture by making use of the nature and qualities of some materials.

Most mediums and modeling pastes, that is, thickeners and modifiers of fluidity, are acrylic based, which means they can be diluted in water. This allows you to mix gesso, thickening gel, and the texture mediums directly with wet acrylic paint, to make innumerable chromatic effects with volume. Oil, being a greasy medium, cannot be mixed wet with acrylic mediums; therefore, the textures are usually created and then painted over with oils when they have dried. If you wish to obtain similar effects with oils you must turn to the oil-based thickening mediums, although they are very different from and must be manipulated differently than the acrylic mediums. Oils and acrylics are used in this book, the only media that can be used for creating textures. When combined with mediums, you can obtain an attractive range of effects so varied that they have become known as a mixed-media technique. Here we will briefly present the main materials and techniques that are used for creating relief effects in paintings. They are not presented in a set order nor are they specifically related to each one of the book's sections, as they can be combined and appear randomly in several exercises.

Strips of overlaid corrugated cardboard repeated in a rhythmic manner.

Sgraffito made by cutting on a rigid support.

Taking Advantage of the Texture of the Support

The surfaces of some materials used as supports already have relief that can be used and incorporated into the painting. Properly primed cardboard, boards, and canvas boards make interesting bases on which to work. In this way, you can paint on a piece of corrugated cardboard, with cutouts of striated cardboard laid in different directions, or on a wood board that has had cuts and sgraffito made in it to emphasize the effect of the wood grain.

Medium and Acrylic Gels

Mediums and gels applied with a brush or palette knife alter the volume and viscosity of the paint. They are composed of an acrylic base or glue that acquire consistency when added to gesso or gel. They modify the fluidity, and when added to acrylic paint they give it a very different consistency and volume than it normally has. Then the paint thickens and can be applied in thick layers of color that are easy to manipulate to accentuate the forms and the character of the paint itself. There are also gels for oils, which are known by the generic name oleopasto, or medium for impasto. They have a translucent and gelatinous appearance, and are the only substances that can be mixed with oil paint while it is wet.

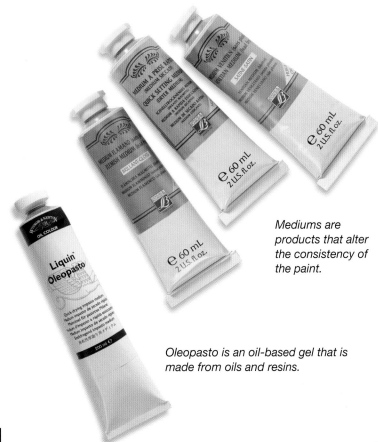

Mediums are products that alter the consistency of the paint.

Oleopasto is an oil-based gel that is made from oils and resins.

Impastos with Brush and Palette Knife

The word *impasto* refers to paint that is applied in thick layers, in a way that the brush marks can be seen clearly. The density of the oil and its total stability after drying are perfect for application with brushes when approaching the construction of a painting. We are talking about an impasto where the brush is used to apply a certain amount of paint to the surface without any intention of dragging or stroking it. Extremely thick impastos can be created by adding oleopasto to create a three-dimensional and sculptural painting. Painting with a palette knife can seem a bit complicated at first, but it just requires picking up the paint with the back of the blade and spreading it with the widest part in a single decisive motion, quickly raising the palette knife when the stroke is finished.

Glazing is done with wax and oil gel.

In the dry technique, undiluted paint is applied to a highly textured support.

Textured Gels and Modeling Pastes

These are gels and mediums to which fillers have been added, for example, washed sands or marble dust and granulated materials. They are very useful for the impasto technique using a palette knife, and absolutely unadvisable if you wish to paint with a brush. The great advantage of these gels and mediums is the thick consistency and their rugged and porous surface. It is very easy to work with modeling paste with the blade of a palette knife, as any incision, stroke, or textural effect will permanently remain on the surface after drying. The final result is very reminiscent of a bas-relief.

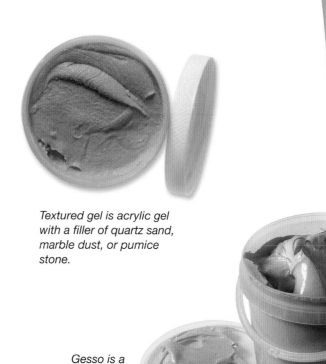

Textured gel is acrylic gel with a filler of quartz sand, marble dust, or pumice stone.

Gesso is a creamy acrylic material.

Granules and Fillers

To create a granulated surface you can incorporate fillers of finely pulverized solid materials in acrylic mediums, oil mediums, or directly into the paint. When mixed, the mediums have a textured surface with uniform granules. The fillers (fine sand, marble dust, carborundum, etc.) are added by eye, without saturating the medium, because this could keep the paint from adhering to the support. The support can also be covered with latex glue and a uniform layer of filler (sand, carborundum, or sawdust) sprinkled over it. This will create a granulated background.

The granular technique is based on incorporating a small amount of filler, in this case, fine glass beads.

Granulated backgrounds are created by covering the support with a uniform layer of filler.

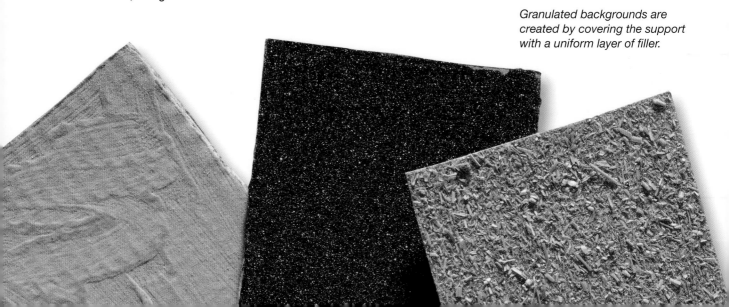

Wrinkles and Folds

A collage of wrinkled papers and fabrics with different weaves, consistency, and color is always a guarantee of texture. Do not limit yourself to just one kind; the results are better if you use cutouts of fabric, paper, and cloth of different qualities and feel, which will create hard and geometric folds or soft and wavy ones. The wrinkles and folds are created by hand with material soaked with white glue or latex before it dries. Tissue paper has unique qualities for creating very expressive transparencies and textures. When it is affixed to any support with water-soluble glue it shrinks and wrinkles in a very natural manner, forming a more or less uniform covering of fine, continuously repeated wrinkles.

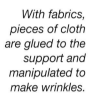

The feeling of volume is created by pushing and gluing wrinkled paper.

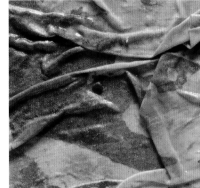

With fabrics, pieces of cloth are glued to the support and manipulated to make wrinkles.

Contemporary artists frequently incorporate organic materials into their paintings.

Relief with Organic Materials

Another option is to incorporate more ephemeral organic materials from nature into the paint, like straw, stones, seeds, and twigs. In a certain manner it is a return to primitivism in art. They are a good alternative to the seriousness of reflective painting and thick and oily impastos. You only have to make sure that they are dry objects, avoiding green buds and flowers that are not well dried. Because of their texture, they are generally used for making Expressionistic interpretations, completely unrelated to academic painting, but respectful of the real model. You can include legumes, cereals, pastas, and rice among the organic materials used to create heavy textures.

Cereals, legumes, and dry pasta mixed with gel, gesso, or mediums add heavy textures.

Reaction of Surfaces to Different Materials

Before beginning the exercises, let's study some effects that we can practice to learn about the possibilities offered by textures and how they can modify the look of a traditional painting. This simple process, in addition to being inspiring, shows you the effects of textures and the differences created between them and traditional or academic painting. To begin we must find different materials that can be of use to us. There is no need to go to an art supply store; materials can be collected in and around the home (cardboard, fabrics, wall coverings, gesso, sawdust, sand, etc.). All these materials can be glued to a small card or piece of cardboard to see their potential. After they dry, a light coat of thinned paint can be applied to emphasize the relief effect. Let's look at some possible textures.

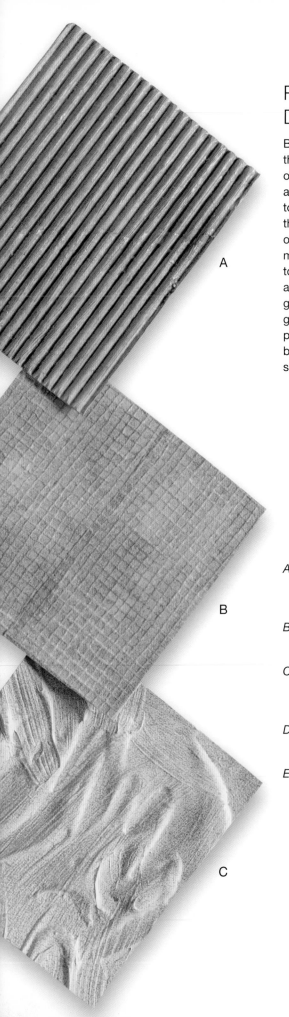

A

B

C

D

E

A. Corrugated cardboard has a rhythmic and repetitive surface. It will adhere better to the canvas if it is thin.
B. Tarlatan is a very fine fabric that can be glued to any surface to create a very distinct grid.
C. A surface can be treated with gesso or modeling paste. After it is dry it can be sprayed with paint to highlight its relief.
D. Sawdust can be adhered to a layer of wet glue to create a very abrasive surface.
E. If very fine sand is used instead of sawdust, the result will be a smoother surface.

Adding Texture to a Dry Painting

You must risk combining different surfaces and relief effects on a painting without hesitation and be aware of the possibilities offered by every surface for achieving attractive compositions with greater expressive interest. Here we take a traditional painting that is already completed and apply textures to it with simple materials that can be easily found: absorbent paper towels, corrugated cardboard, and sand. The physical characteristics of each material should be related to the real surface of the model that they will represent. This means that the materials should have a certain affinity with the texture of the surface of the real model.

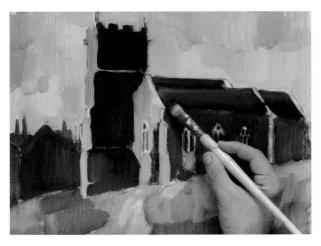

The starting point of this exercise is an oil that was painted a few weeks before in the traditional manner. When adding texture it should be completely dry.

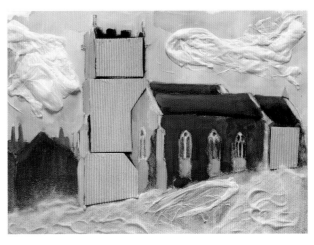

The materials are glued with latex. Then you must wait for at least an hour for the glue to dry completely before painting over the textures.

A layer of oil paint integrates the new additions of texture into the work as a whole. Now the interpretation seems more up to date and modern.

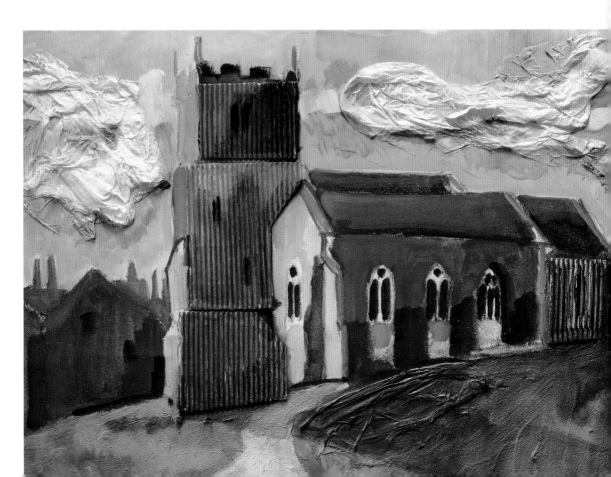

Wrinkles are beautiful:
paper and fabric

When paper is affixed with glue to any surface it naturally shrinks and wrinkles, forming a more or less uniform surface of small, continuously repeated creases. While tissue paper possesses unequaled qualities for transparencies and relief textures, there are other materials like paper towels that can also play an important role. Here is shown a still life done in oil.

When the paper towel is varnished, the wrinkles are bathed in a patina of ocher.

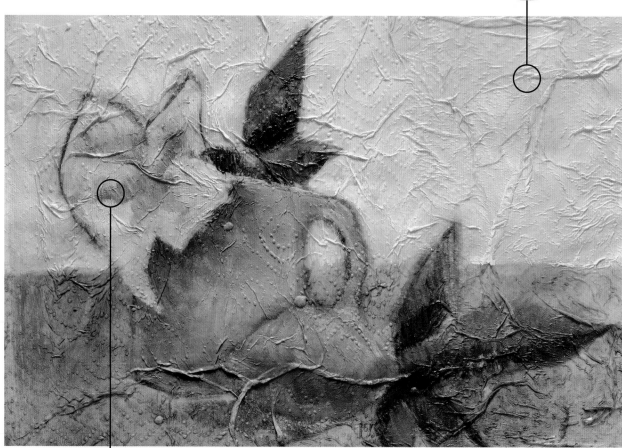

The varnish keeps the paper from being too porous and makes it easier to paint. The brush will glide easily over the textured surface.

The wrinkled, absorbent paper towel offers many more textures than tissue paper. They will stand out when painted with undiluted color.

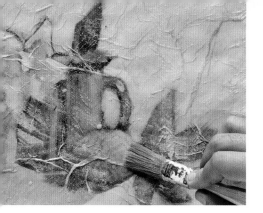

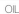

Varnish is a good alternative to white glue or latex for adhering the paper, in this case, an absorbent paper towel, to any drawing or painting.

A piece of fine cloth adds more striking and beautiful wrinkles, but it requires more glue to keep the folds from standing out too much.

If you use varnish instead of glue, it will add shininess to the creases.

Glued paper can be used to contain elements underneath, like straw, sand, and twigs, and to paint them more easily.

White tissue paper is very transparent. It can add many tiny wrinkles to a surface that is already painted.

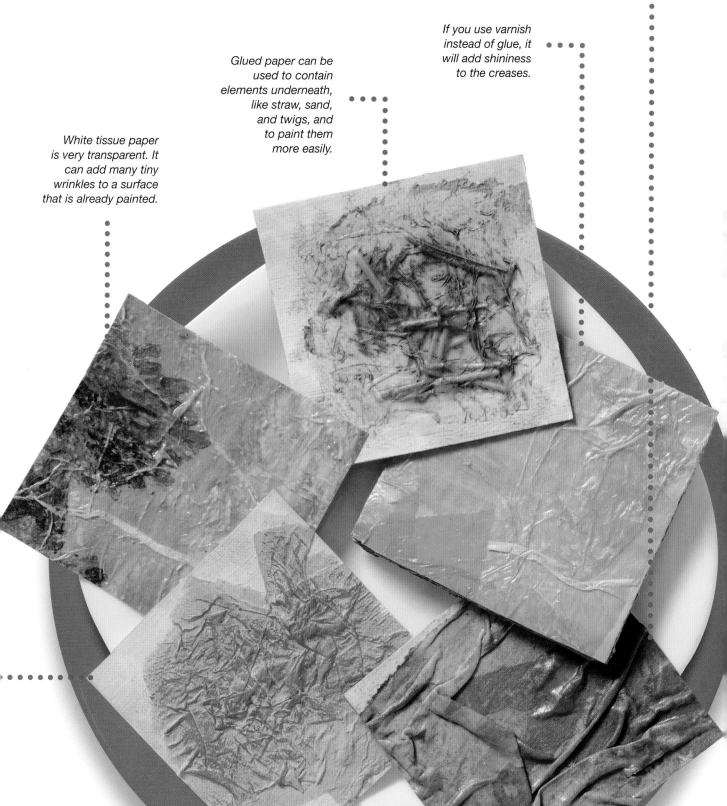

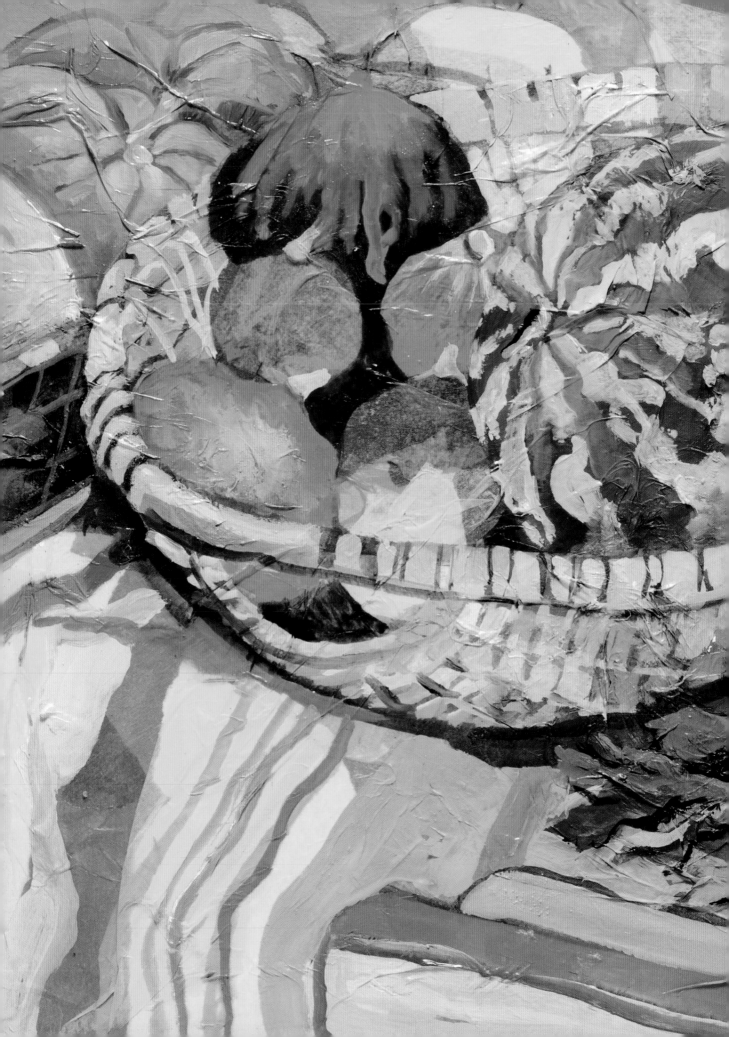

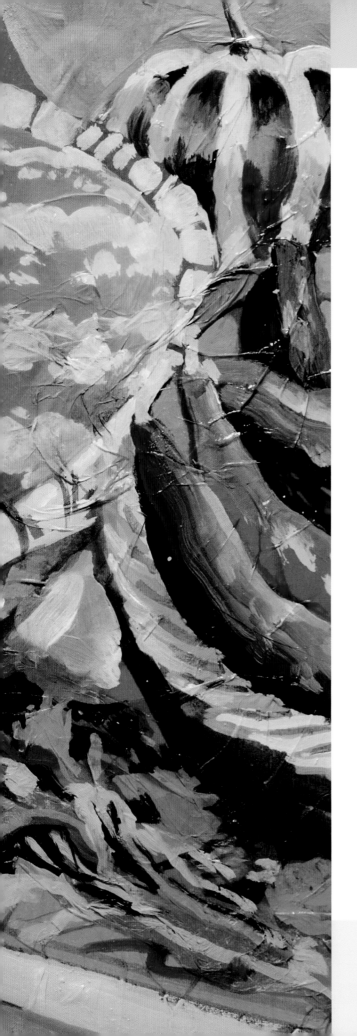

Still Life
with Tissue Paper and Oil

Let's begin with an attractive still life painting that has a smooth surface. A surface texture that is full of tiny wrinkles is incorporated into the painting, making it casual and very expressive at the same time. The texture is made with tissue paper, which is available in many colors and creates a texture that incorporates as many folds and creases as you wish. They are barely raised above the surface and are easy to paint. The colors of the paper mix with the brushstrokes of oil paint and highlight the saturation of the colors.

DIFFICULTY	PAINTING TIME
Low	6 hours

INGREDIENTS

- Container of latex
- Oil paint:
 yellow ocher
 cadmium yellow
 emerald green
 turquoise blue
 mixed green
 cobalt violet
 cadmium orange
 titanium white
 cyan blue
 burnt sienna
 sap green
 ivory black
- Sheets of colored
 tissue paper:
 yellow
 orange
 red
 green.

UTENSILS

- Canvas board
- Fine and medium
 filbert-tip brushes
- Fine and medium
 round-tip brushes

Preparation

1 Tear the tissue papers by hand and glue them to the canvas with latex. Then go over the edges with a medium round brush to keep them from raising.

2 The colored sheets should not be affixed randomly. They should be composed as if they were a collage. Each new addition of color should relate to the real-life model.

3 Each piece of paper is treated as if it were a brushstroke of paint that is layered over the others to form glazes. It is not necessary to represent the vegetables with the wrinkled paper; it is a matter of constructing a background, a base of color to paint over.

1
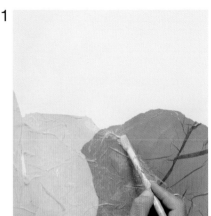

2
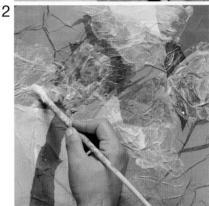

3
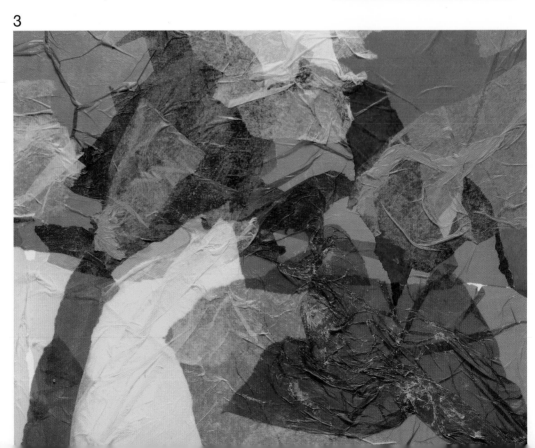

4

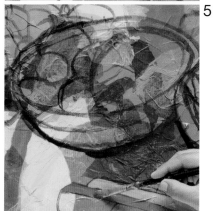

5

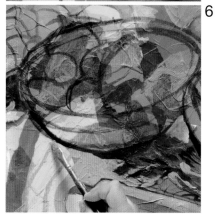

6

4 Roughly sketch the elements of the still life with black thinned with turpentine and the round brush. Nearly all of the elements are based on circles and ellipses.

5 Make the first strokes of gray and blue with the filbert brushes. They will define the dark bases of the objects and paint the wood easels.

6 Work on the tablecloth with cadmium yellow and a touch of green. To give it the proper shape, complete the shapes of the colored paper with paint. The upper area is then painted with medium violet.

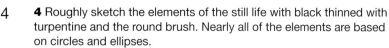

Advice

Always work with thick paint, since if it is diluted you will run the risk of it spreading uncontrolled across the paper.

7 Now work on the volumes of the fruits and vegetables, first the largest green squash, with emerald green, ocher, and yellow. It should be painted as if it were a sphere, creating a gradation from dark to light.

7

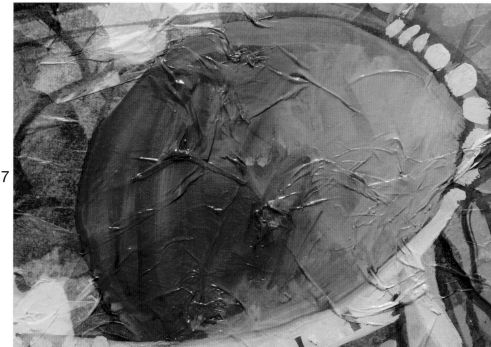

8

9

10

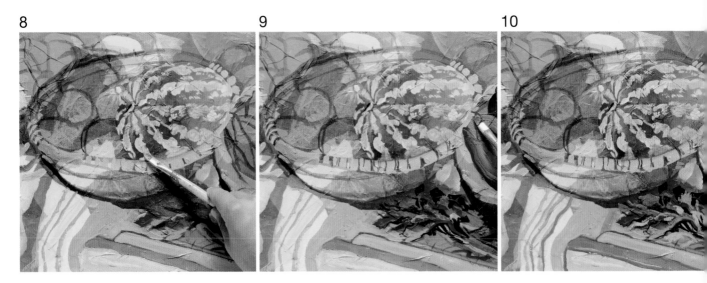

8 Paint the yellow stripes of the squash holding the brush nearly horizontally. Rotate the brush to create the zigzag shapes with the paint.

9 Paint the turnips on the right with violet gray, reserving the red in the background for the darker areas. The bunch of parsley at the lower right is constructed with green brushstrokes of different intensities.

10 Add turquoise and violet tones to the parsley leaves, then finish painting the lines of the tablecloth with cyan blue.

11 Using medium orange and dark violet, suggest the small squash in the basket. The woven basket is painted with light gray, which is altered with touches of blue, violet, or orange, leaving small spaces for the background color to show through.

12 After the main elements are resolved, you only have to finish the background. The rest of the vegetables can be suggested with grayed colors. The colors should be more or less flat and have very little contrast that would distract the eye from the main elements. The blues and violets are most appropriate for finishing the background.

12

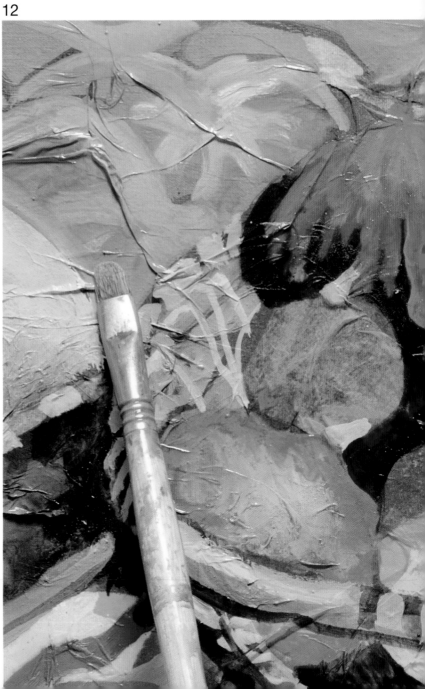

11

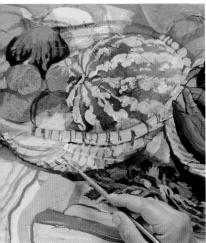

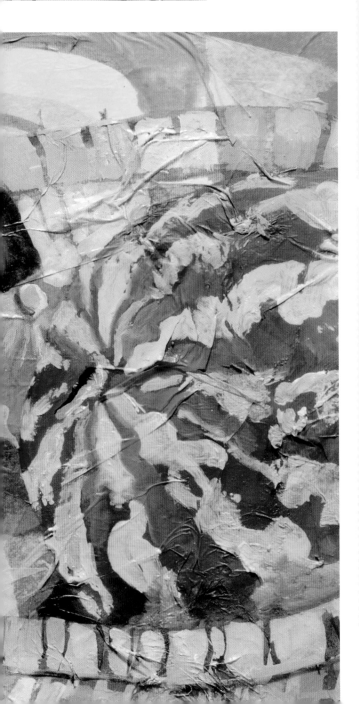

RECIPE CARD 1

THE QUALITIES OF TISSUE PAPER

Tissue paper is easily wrinkled, its colors can be mixed by overlaying the sheets, and oil paint adheres very well to its surface. No other paper offers the same advantages.

RECIPE CARD 2

MICROFOLDS

The main advantage of tissue paper is the number of interesting microfolds or wrinkles that are created by wetting it with glue. To remove them you can just paint over them with paint thinned with turpentine.

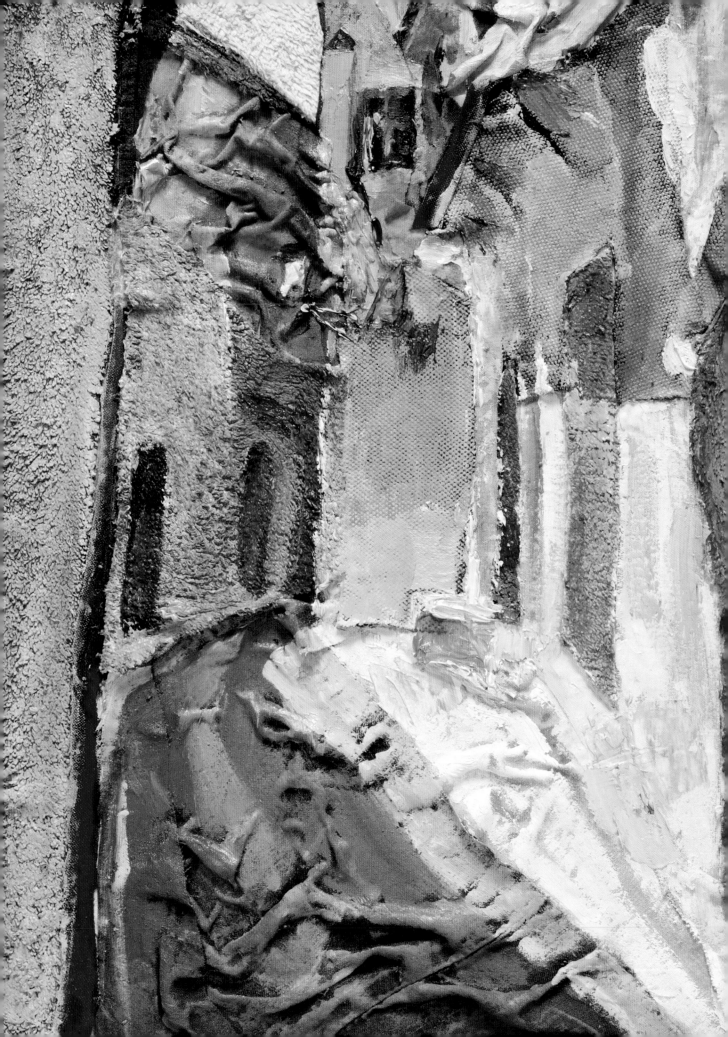

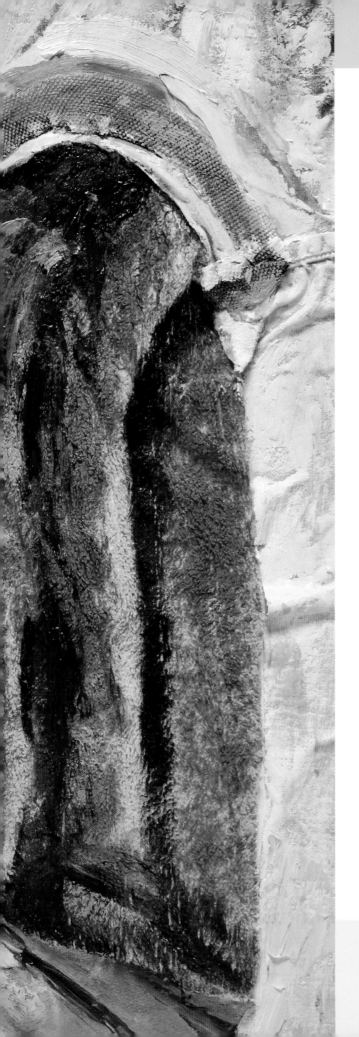

Collage
with Fabrics
of Different
Textures

Fabric and cloth of different weaves, textures, absorbency, and consistency can be incorporated into paintings. They always guarantee good texture. They should be glued to the support with acrylic base, latex, or white glue. While they are still wet, the artist can manipulate the fabric to create any wrinkles he or she desires. After they dry, the fabric and cloth are then painted with acrylic colors to create an attractive interpretation of this urban scene.

DIFFICULTY	PAINTING TIME
Low	6 hours

INGREDIENTS

- Jar of latex
- Acrylic colors:
 yellow ocher
 burnt sienna
 cyan blue
 ultramarine blue
 titanium white
- Fabrics of different
 textures and colors

UTENSILS

- Canvas
- Small wide brush
- Fine and medium
 filbert-tip brushes
- Flat synthetic
 brushes (medium
 and wide)
- Metal palette knife
- Graphite pencil

Preparation

1

2

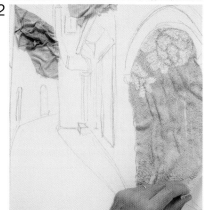

3

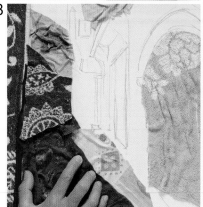

4

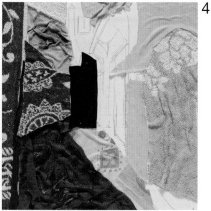

1 Sketch the alley with the graphite pencil. It is very important to correctly indicate the perspective and the locations of the doors and windows.

2 Apply a base of latex on the support with the small wide brush. While it is still wet, begin adhering pieces of fabric that have previously been cut out with scissors to shape them to fit the model.

3 You do not have to limit yourself to just one kind of texture. The collage will be more attractive if it has fabric pieces of different quality and feel, which will create both hard geometric folds and soft flowing ones.

4 Press the surface of the fabric to make wrinkles that can be incorporated into the representation of the model. Printed fabrics add a graphic interest to the scene.

5

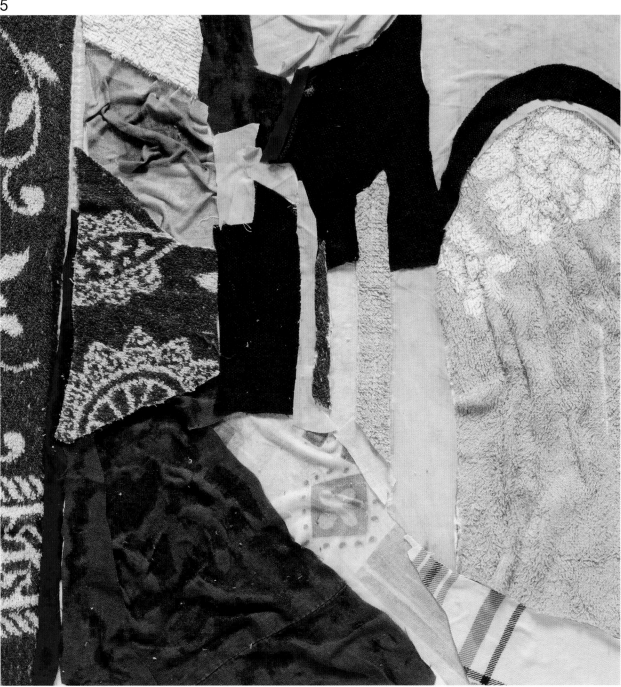

5 As you progress, the pieces of fabric should be smaller and more accurate, to better illustrate the model. The darker fabrics should be used in the more shaded zones of the facades. Do not worry about the colors, as they will be adjusted with the paint.

Advice

Use a lot of latex to glue the fabric to the support. Then apply a layer of diluted latex on the fabric to reduce the porosity and make it easier for the paint to adhere.

6

7

Do not completely cover all the fabric with paint. The final result will be more attractive if the colors can be seen through the brushstrokes.

6 Begin painting the facades with cyan blue mixed with a large amount of white. The absorption of each kind of fabric will determine how much you dilute the paint; for example, to cover a rough fabric you will need more paint.

7 Use a medium blue to cover the printed fabric and unify the color of the walls on the left side of the street. Mix a dark color with ultramarine blue and burnt sienna to indicate the lines of the rooftops and a couple of the doors.

8 Paint the rooftops in the background using a fine brush and a mixture of ocher and sienna. The paint will adhere better to this fabric than to the towel. Using the same color mixed with white, match the facade on the left, reserving a square shape on the dark cloth to represent a window.

8

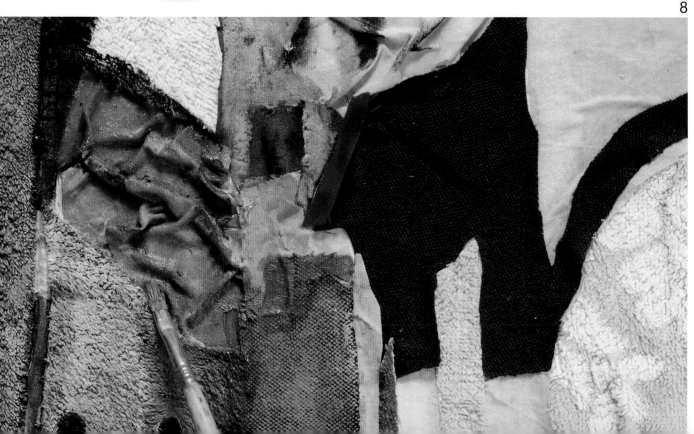

9 Use the same sky blue from before to paint the arcade on the right. The wood beams are the same color as the fabric and emerge as the space and air surrounding them is lightened. It is a matter of painting the light around the beams.

10 Now it is time to paint the sunlit walls. Illuminate the surface of the street and the facades on the right side with barely diluted titanium white, so that the yellow color blends into the whitened areas.

11 Paint the inside of the window opening and the nearest doorway with ultramarine blue. The paint should be diluted when painting on a thick fabric.

9

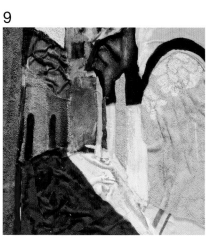

10

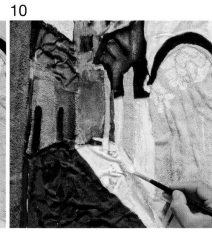

11

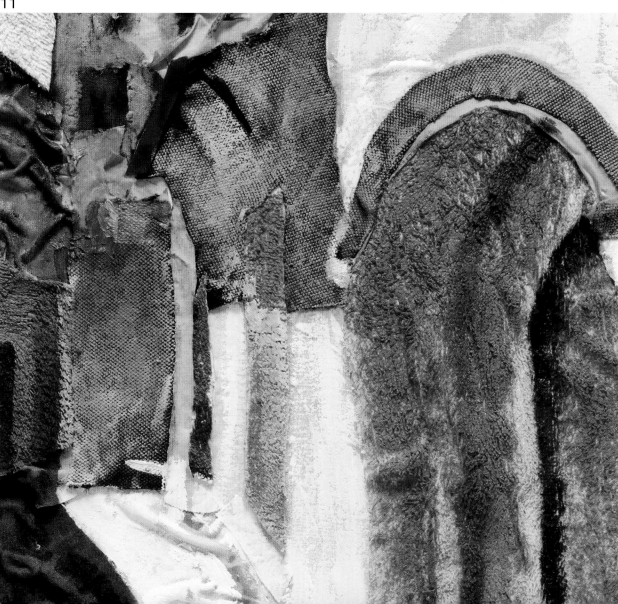

12

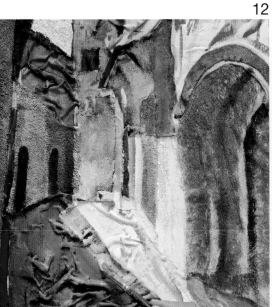

13

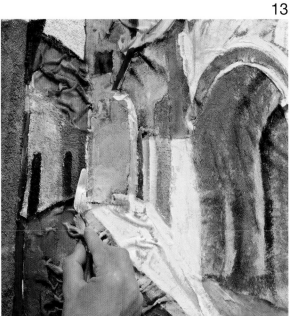

14

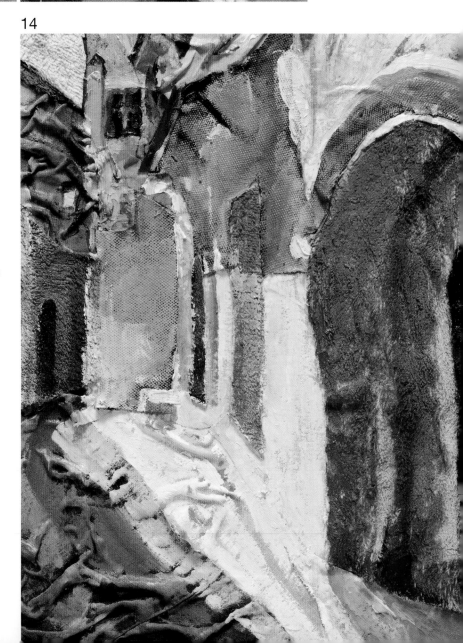

12 Paint the half-light of the street with lightened ocher. The paint should be thick so that it is mainly deposited on top of the creases. Lighten the rear of the alley with a mixture of blue and white, and add some strokes on the facade to the right.

13 The final applications are made with a palette knife. Pick up thick white paint from the palette with the back of the blade and apply it to the painting to project intense linear strokes.

14 The lines of some of the windows and the arch over the door on the right are also strengthened using the palette knife. Use gray and brown brushstrokes to adjust the tones of the houses in the background and the surface of the street.

RECIPE CARD 1

THICK AND DILUTED PAINT

Based on the density of the paint when painting the cloth, the result can go one way or the other. Notice here the tonal scale moving from the most diluted paint to the thickest.

RECIPE CARD 2

REACTION ON EACH FABRIC

Every fabric accepts the paint differently. To test them, all you have to do is make the same brushstroke on a cotton cloth and on a towel.

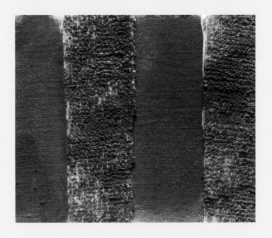

RECIPE CARD 3

MAKING WRINKLES

Wrinkles do not appear spontaneously; the artist has to make them by manipulating the fabric when it is impregnated with glue. After the wrinkles have dried they become permanent.

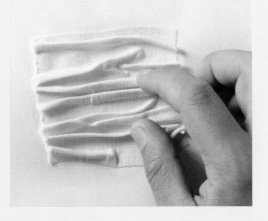

RECIPE CARD 4

FABRIC TOO DARK

If the fabric is too dark, it should be painted with light or bright colors after first covering it with a layer of white gesso. This way the reds will be very intense and will not be contaminated by the color of the fabric.

Exploring the folds

You must risk using different materials, no matter how surprising the result may be. They will supply you with a great variety of folds and wrinkles and help you make use of all the possibilities of each surface. Based on this it will be easy to create original relief effects that are very interesting visually. Each material, according to its consistency and malleability, has different kind of creases that can range from the very geometric and structured aluminum foil to the multiple small wrinkles of transparent plastic wrap. Both are typically found in the kitchen, and they can be added to your glossary of art materials. Next we present a simple still life painted with acrylics, interpreted in a daring contemporary style.

Any fabric can be impregnated with very liquid latex and incorporated into the canvas. While it is damp you can adjust it and form any folds you need.

Rectilinear folds have been created with a piece of felt to form a series of pleats.

Sheets of aluminum foil are harder and more geometric. The surface can be covered with a coat of gesso to remove the shininess before painting it.

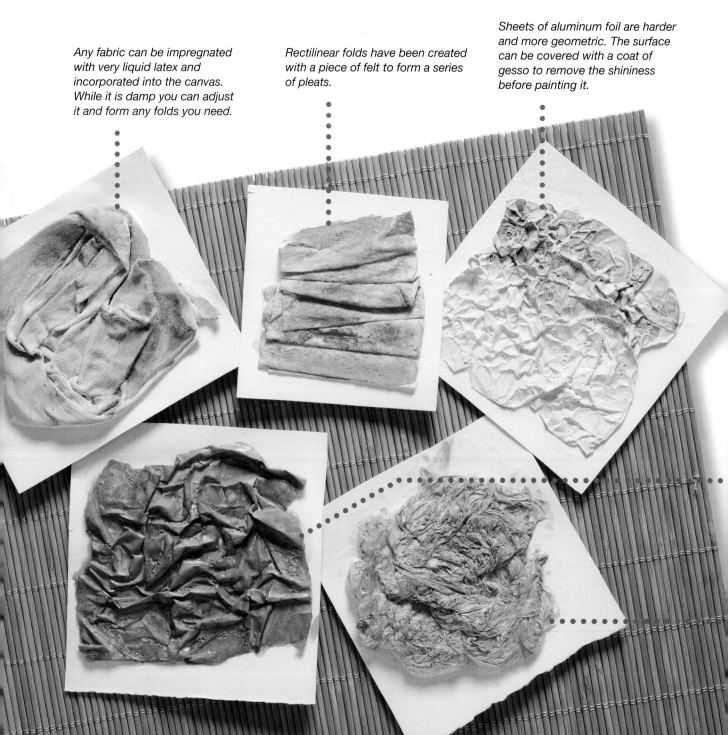

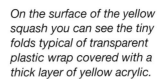

On the surface of the yellow squash you can see the tiny folds typical of transparent plastic wrap covered with a thick layer of yellow acrylic.

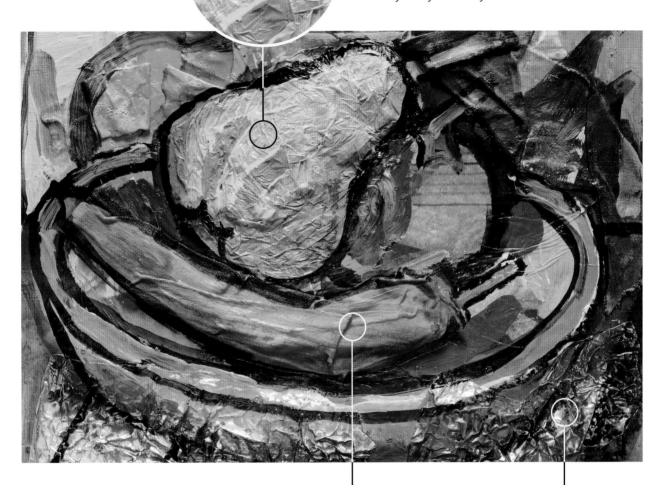

The blue paper has been hardened with a coat of latex. The wrinkles are similar to mountains. When a color wash is applied it is deposited in the valleys formed by the folds.

Gluing plastic wrap with latex creates many tiny wrinkles. Adding a wash of any color makes the wrinkles in the plastic more evident.

The volume of the pepper was made with a large piece of fabric that was rolled and soaked with latex.

You can see aluminum foil incorporated into the lower area. It was not covered with gesso so that the shininess would be visible through the layer of paint.

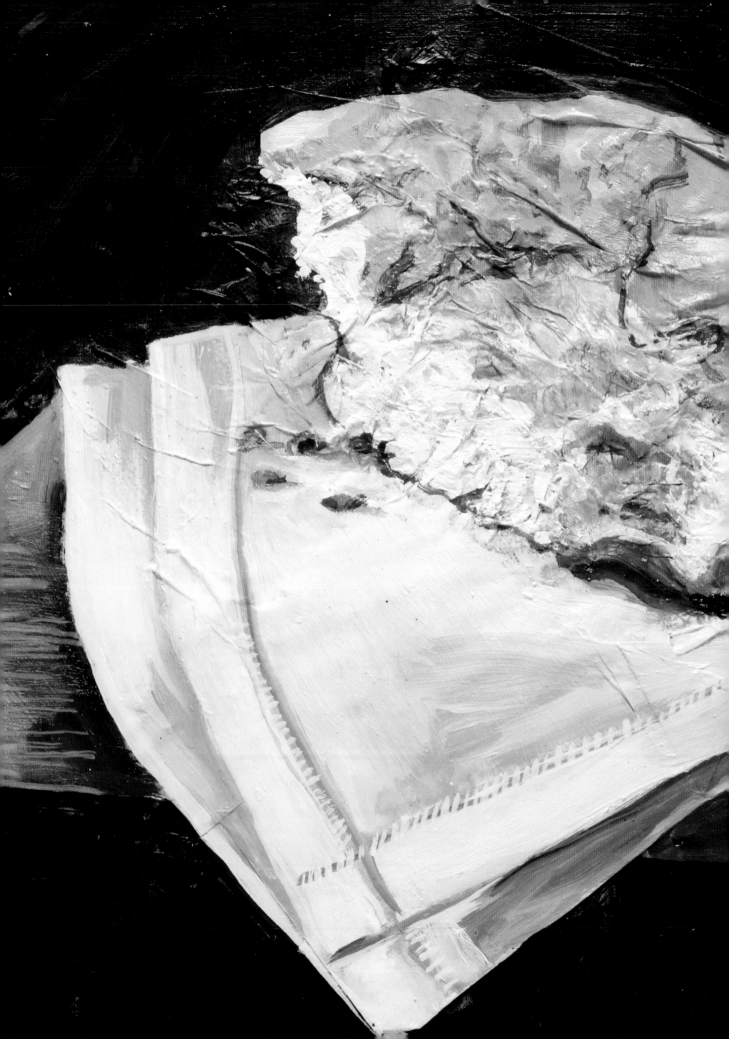

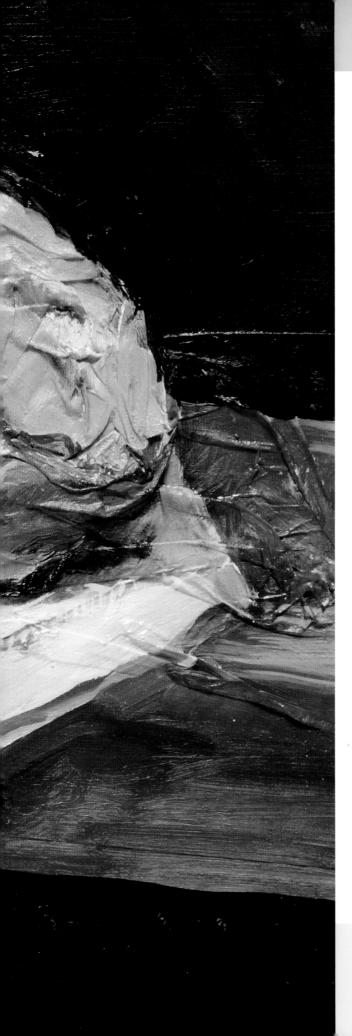

Volume
with
Newsprint

I n this still life you will attempt to increase the volume of the object and its shape using wrinkled newsprint. Newsprint is a throwaway material of little value and very easy to obtain, and when it is mixed with white glue it can be used to create striking bas-relief effects on the surface of the support. (The use of newsprint in this exercise is designed to focus the artist's attention on day-to-day materials that he or she would not have thought to have artistic value.)

DIFFICULTY	PAINTING TIME
Medium	5 hours

INGREDIENTS

- Latex glue
- Oil colors:
 burnt umber
 yellow ocher
 burnt sienna
 titanium white
 permanent violet
 ivory black
- Gesso
- Newsprint

UTENSILS

- Canvas
- Medium and wide
 hog-bristle brushes
- Fine, medium, and
 wide filbert brushes

Preparation

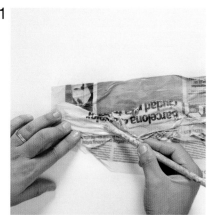

1

1 To create relief with newsprint you must first take a few sheets and wrinkle them, accumulating the folds. Cover the canvas with a large amount of glue and affix the paper to the surface.

2 Form balls of wrinkled paper and press them onto the glue on the surface. Cover the balls of paper with a coat of very diluted latex to dampen the paper and make it a little more malleable.

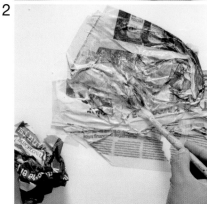

2

3 The paper addition should make sense and follow the direction of the elements that they are representing. To finish, flatten the wrinkled paper with a brush charged with thick undiluted latex glue, which will flatten the relief and harden the surface.

4 Wait one hour for the glued paper to dry, then cover it all with a thin coat of white gesso so the oil paint will adhere better.

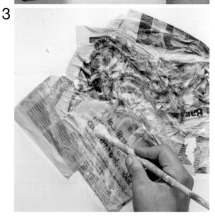

3

4

5

6

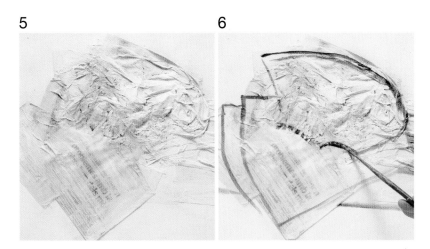

5 Make sure that the paper looks more wrinkled on the bread and smoother on the napkin. The irregularities will help illustrate the crust of the bread.

6 Since it is simple, the drawing can be made directly with a brush. Trace the outlines of the main forms with diluted oil paint. The representation will be very schematic.

7

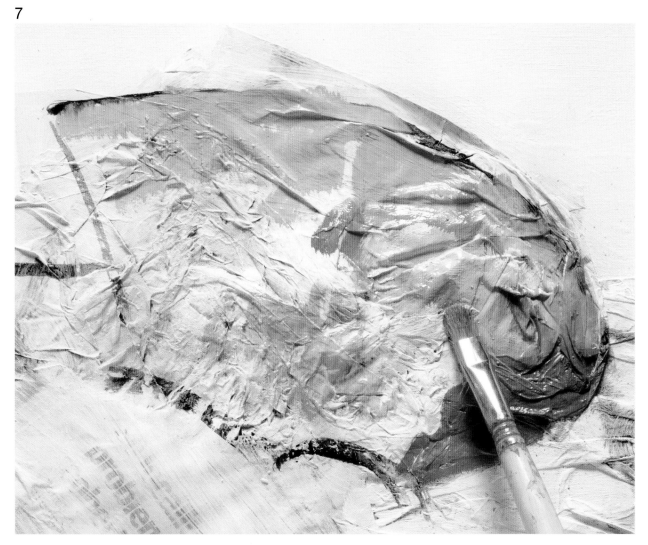

7 Alternate shades of pure yellow ocher with white mixed with a touch of violet to paint the crust of the bread. The inside is painted with white and a bit of ocher. At this point the oil paint is not diluted.

8

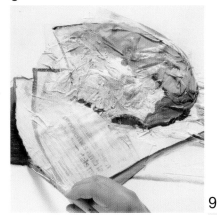

8 Paint the dark line underneath the piece of bread with burnt umber. Then paint the wood shelf, alternating three colors: ocher, sienna, and black.

9 The darkest part of the bread is painted with burnt umber, while the upper part is resolved with a mixture of ocher and sienna. It is important to establish a clear tonal difference between the planes to indicate its volume.

9

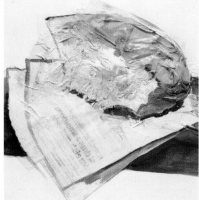

10

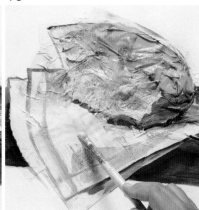

11

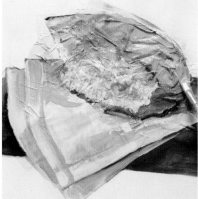

10 The beige of the napkin is made with a mixture of ocher, violet, and a large amount of white. It is only applied to the most shaded areas to better describe the napkin's folds and the way it hangs over the shelf.

11 The areas of shadow on the napkin should be completed by adding grays that have a little violet. This same color is then painted on the crust. Handle the brush carefully when painting the inside of the bread so that the gray is only deposited on the high areas of the wrinkles and adds to the feeling of texture.

12 Use the finest brush to draw the cracks in the bread's crust. We have used burnt sienna with a tiny bit of black. The contrast of light and shadow should be stronger on the crust.

12

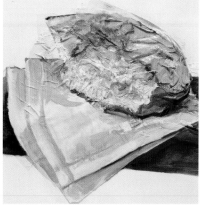

13 Use titanium white to bring back some light areas on the napkin and the bread. The brushstrokes should be thicker on the bread, and made using the tip of the brush. On the napkin the strokes should be longer and more fluid.

Advice

Use the fine brush to outline the piece of bread with a thin dark line. The line will disappear when the background is painted black, but it will remain around the edge of the bread.

13

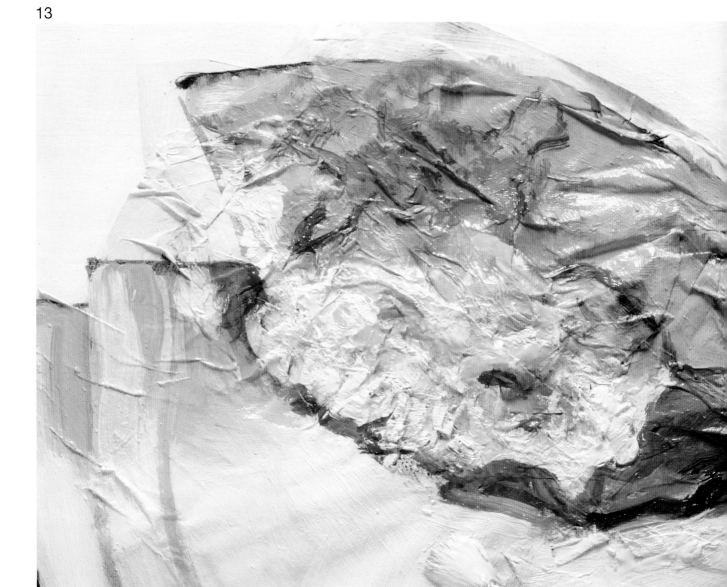

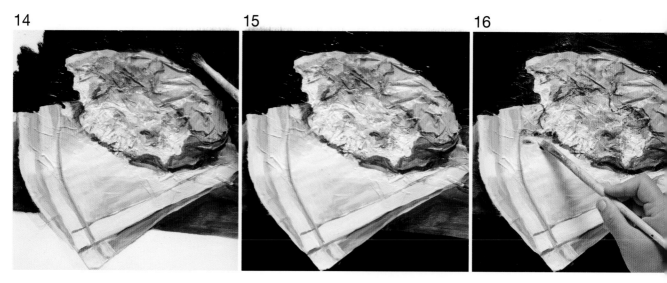

14 **15** **16**

14 Before continuing with the details, cover the background with dense ivory black. The color is important for creating the outline of the model, so you must paint this area carefully.

15 The flat black background adds importance to the main element of the still life, creates its outline, and highlights its volume. When the black is applied to the wrinkled paper it cancels the relief effect.

16 Use a filbert-tip brush to work on the texture of the inside of the bread, making hollows with burnt umber. Paint the breadcrumbs on the napkin with a few dabs of paint.

17 Finally, use a very fine brush to suggest some details on the napkin to make the materials more realistic. Use the same brush to paint the grain on the wood shelf.

Suggestions

RECIPE CARD 1

DUSTED
NEWSPRINT

If you wish to emphasize the possibilities of the newsprint even more, you can cover it with latex and add a coat of fine grain filler, which will give it a very unique look.

RECIPE CARD 2

PAPER PASTE

Cut the paper in small pieces and submerge them in water and glue for a day. They will turn into a paste that can be applied with a brush.

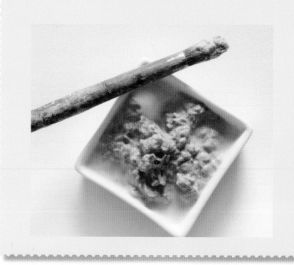

17

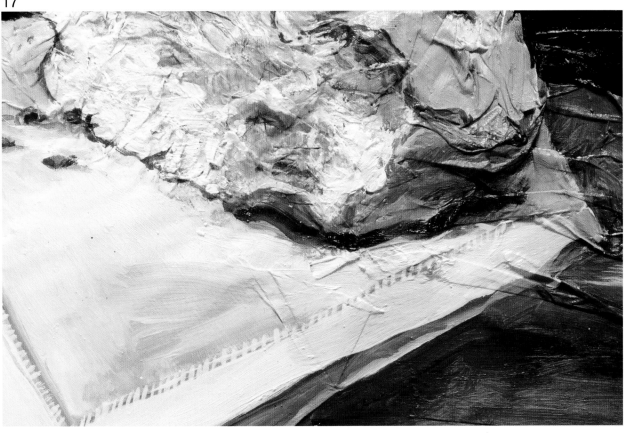

RECIPE CARD 3

CONTRASTS
WITH WASHES

*The wrinkled and cracked effect of
the paper can be strengthened with
a wash of any color that will
contrast with the base.*

RECIPE CARD 4

LINES

*Making lines on a surface with a lot of relief is
not easy. If the brush does not have much
paint that is not very wet, the lines will be
rough and broken. The lines will become
more intense if the paint is more diluted.*

Fillers That Are Added to the Paint

Fillers are finely ground solid elements that are added to the paint, either mixed a little with the medium or mixed directly with the paint to modify its viscosity and roughness. You must take some precautions when using fillers: avoid using organic fillers that can decompose, and do not use chemicals or salts that will cause the canvas to deteriorate. Here we show a painting made with oil and acrylic and with three different types of fillers.

Mica is a heavy-grained filler that reflects light, creating a characteristic silvery reflection. It is usually sold in gel form.

Carborundum has a diamond-like sheen, but it greatly darkens the colors. Like any filler it is available in three modes: fine, medium, and (in this case) heavy grain.

Fine sand, like this quartz, is the most commonly employed filler because it is easy to obtain and moderately priced.

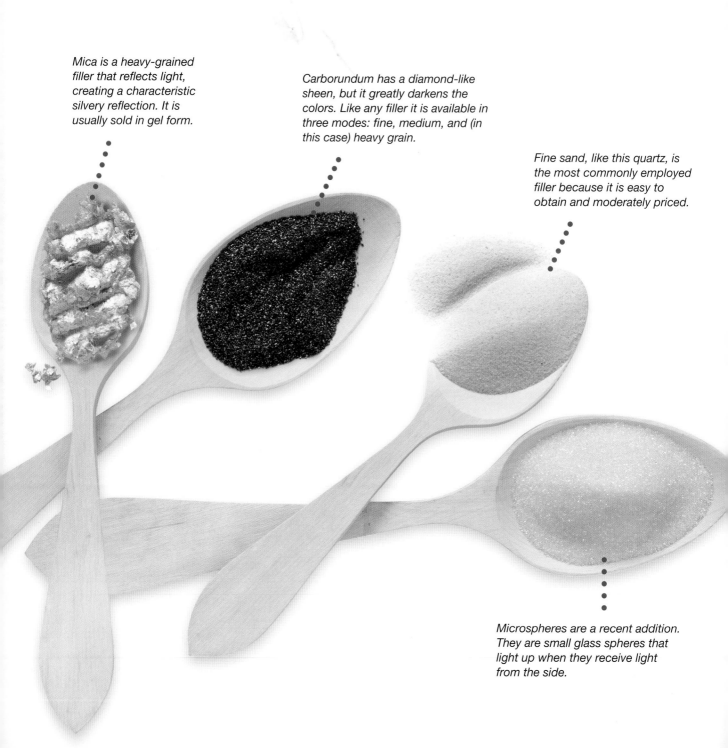

Microspheres are a recent addition. They are small glass spheres that light up when they receive light from the side.

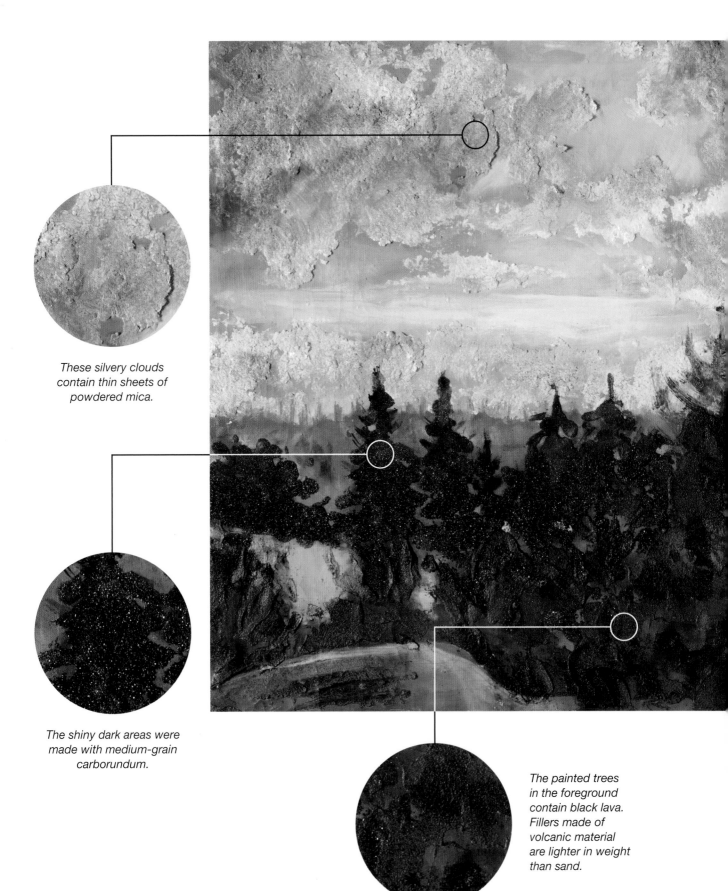

These silvery clouds contain thin sheets of powdered mica.

The shiny dark areas were made with medium-grain carborundum.

The painted trees in the foreground contain black lava. Fillers made of volcanic material are lighter in weight than sand.

Collage
with Paper and Microspheres

Artists tend to replicate on canvas the textures and folds that are found in nature. The grass, the rocks, or the bark of the tree are sources of visual stimulus and an unending source of inspiration. This third, very simple practical exercise incorporates blotting paper collage on the support to create folds and wrinkles that combine with the glass microspheres; this way, the texture produced by the crumpled paper alternates with the rough granulated effect.

DIFFICULTY	PAINTING TIME
Low	6 hours

INGREDIENTS

- Latex glue
- Oil paints:
 burnt umber
 Prussian blue
 ivory black
 yellow ocher
 cadmium yellow
 permanent green
- Blotting paper
 (paper towel or
 toilet paper)
- Crystal
 microspheres

UTENSILS

- Cardboard
- Graphite lead stick
- Filbert brushes
 (thin, medium,
 and fat)
- Round, fat brush

Preparation

1
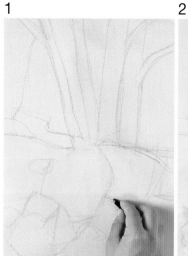

2
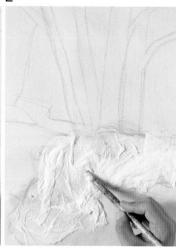

3
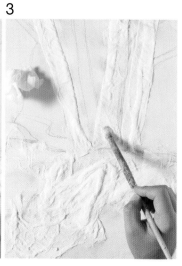

4

1 With the graphite stick draw
the first lines of this rural landscape.
First draw the rocks with their round
forms, from which will extend the
diagonal lines that form the trees.

2 Tear out pieces of blotting paper
and glue them to the support with
thick glue. You can add a small
amount of water to the glue to
create more wrinkles.

3 Fold the blotting paper in the
shape of a tube and glue it to
form the main tree trunks, creating
a bas-relief that stands out against
the surface of the painting.

4 To make sure that the paper
wrinkles remain permanently,
cover them with a thin layer of
glue to harden them. While
the glue is wet sprinkle the
crystal microspheres on the
rest of the surface.

5

6

7

8

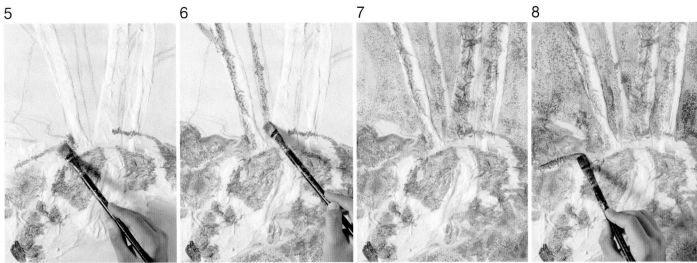

9

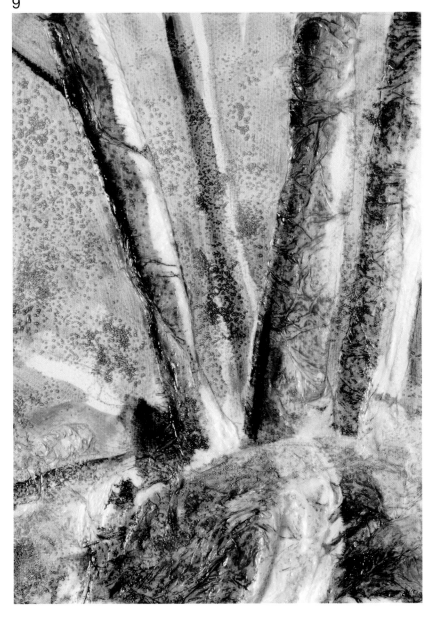

5 The first color applications are very diluted. Create the dark areas of the rock grouping with burnt sienna and a touch of black.

6 Paint the grass with a diluted mixture of green and ocher, and the shadows of the tree trunks with brown paint. The microspheres produce a very characteristic granulated effect over the painted areas.

7 The first goal is to cover the entire surface of the support with diluted paint to create a foundation from which to work. The most illuminated areas will be left the color of the paper.

8 Over the prepainted base add new brushstrokes with oil paint diluted with mineral spirits. Darken the background with gray, ocher, and a little bit of green. These new applications highlight the microspheres even more.

9 With Prussian blue and black darken the left side of the trees. Use both colors combined to define the volume of the rocks. The diluted paint makes the folds and wrinkles of the paper stand out more.

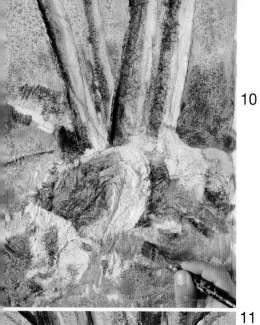

10

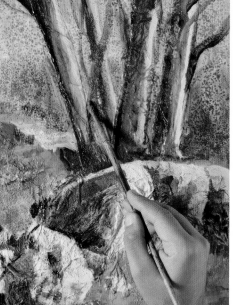

11

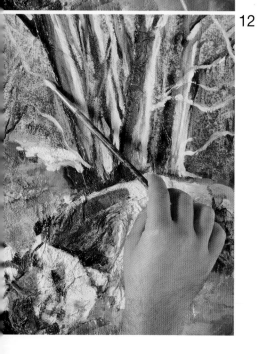

12

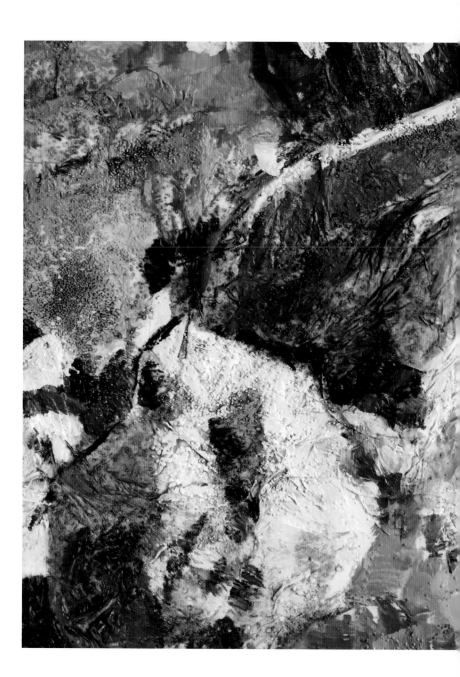

10 Paint the grass with a flat brush, applying the brushstrokes with the tip of the brush to project groups of lines, which look like grass when they overlap.

11 Highlight the profiles and the linear effect of the main tree branches with a thin brush. The line should be rounded, continuous, and sinuous.

12 Paint the thinner branches with the tip of the brush held at a steep angle, holding the brush at the very end to avoid applying too much pressure. Rotate the brush as you continue making the lines.

13

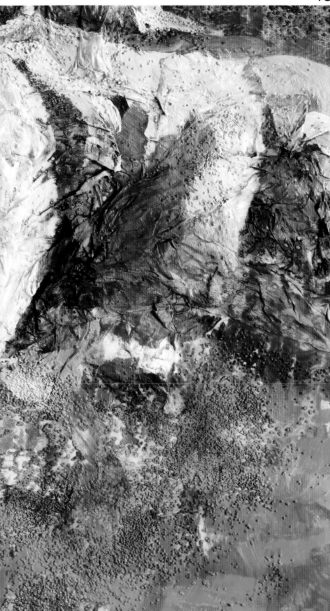

RECIPE CARD 1

AROUND THE MICROSPHERE

When you look at a surface covered with microspheres you will notice that the diluted paint runs to the sides, around the sphere, which is transparent. If you wish to cover them, you must use thick paint.

RECIPE CARD 2

TEXTURING THE ROCKS

For the rocks showing greater texture you will have to charge the brush with thick paint and cover only the highest parts of the wrinkles. Here you may try the technique with other colors that stand out more.

13 As you approach the end of the project, the applications of paint should be thicker and less diluted, which will enhance the colors of the grass and the contrast of the rocks.

Advice

Do not rub with the brush excessively because the microspheres create a very abrasive surface that will quickly wear it out.

Nontraditional Textures:
Noodles, Rice, and Others

Various modeling pastes are available that incorporate coarse material such as mica gel or paste with coarse-grained marble. These pastes are very attractive to artists seeking new relief effects, especially when it comes to getting a very rough surface full of shapes and shadows that cause an expressive effect unobtainable with paint only. Another option: adding textures to customize the modeling paste or gel using rice, noodles, or other coarse-grained material can add surprising new effects, as shown in this work done in oils.

The heavy textured gel is made up of acrylic and marble dust. It creates a very rough surface.

Modeling paste mixed with noodles. You can add ingredients to the paste as long as they are dry.

Mica gel medium is gray and creates a surface that is characterized by metallic reflections.

Rice is a natural ingredient that provides a thick texture that is easy to paint when mixed with gel, latex, or paste.

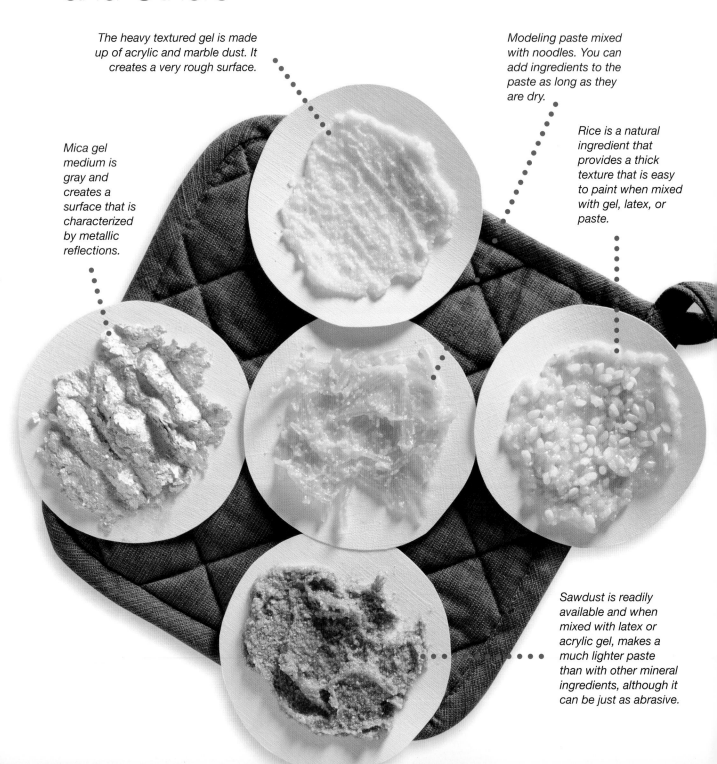

Sawdust is readily available and when mixed with latex or acrylic gel, makes a much lighter paste than with other mineral ingredients, although it can be just as abrasive.

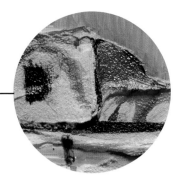

White rice, with its round surfaces, can be easily integrated and takes paint very well.

A surface made of noodles and modeling paste creates a surface full of nooks, crannies, and shadows. It is very suitable for representing vegetation.

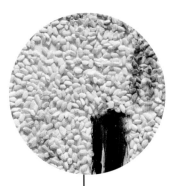

We have created the upper part of the building with gel mixed with beach sand. The finer texture makes it possible to control the impasto better.

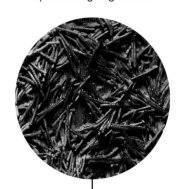

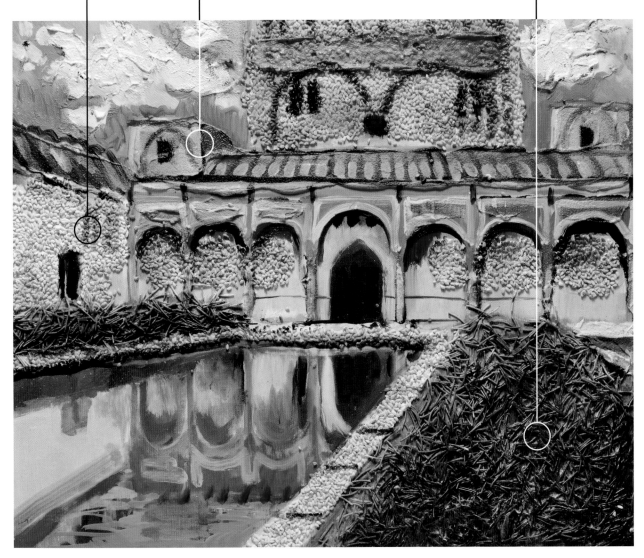

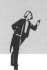
Sky
with
Heavy
Texture

When you add bright and shiny fillers like mica to the paint or even very unusual fillers like rice, thin noodles, etc., the painting acquires an expressive character that is impossible to achieve with other media. For example, the reflection of very textured and rough surfaces varies according to the angle at which the light shines on them. If you want to make a conventional painting, working on a surface with these characteristics is not an easy task; however, if you wish to create an original and striking representation, this is the ideal approach.

DIFFICULTY	PAINTING TIME
High	30 hours

INGREDIENTS

- Acrylic paints:
 ultramarine blue
 titanium white
 burnt umber
 phthalo green
 raw sienna
 permanent green
 emerald green
 royal yellow
- Mica gel
- Thick modeling
 paste
- Noodles and rice

UTENSILS

- Canvas
- Metal palette knife
- Medium, round-
 bristle brush
- Medium, flat filbert
 brush
- Graphite lead
 stick

Preparation

1

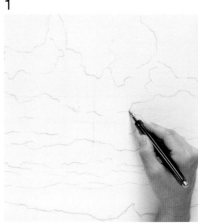

2

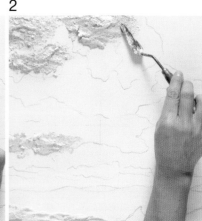

3

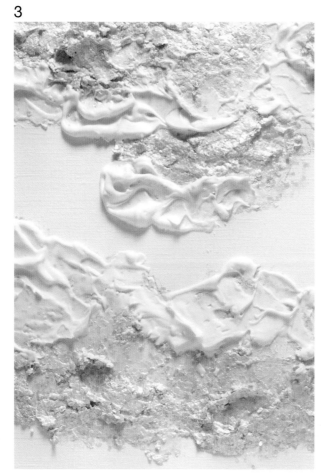

1 In this landscape the sky takes center stage. Drawing it is very easy; just roughly sketch the outlines of the clouds with graphite. Use more broken lines to draw the outline of the mountains.

2 Apply mica gel medium over the clouds to form thick impastos. Flatten and model the paint with the underside of the palette knife blade until you are satisfied with the shape, avoiding too many raised areas and corners.

3 Complement the previous applications of mica gel with others made of thick modeling paste, which create voluminous impastos with more rounded profiles. Their surface is smoother and not as abrasive.

Throughout the process, it is important to keep the blade of the palette knife submerged in a jar of water to prevent the gel and the paste from drying out. Forgetting to do this can ruin the smoothness and effectiveness of the blade.

4

5

4 To complete the volume and fluffiness of the clouds alternate the mica gel with the modeling paste. At the bottom of the painting, sprinkle a few grains of rice and glue on thin noodles over the wet surface. This will give that area a unique texture.

5 Continue working on the sky until the clouds are completed. To make sure that the grains of rice and the noodles are firmly attached to the painting, press on them with the palette knife loaded with modeling paste.

6

6 Wait a full day for the texture to dry, and then begin to paint. Apply ultramarine blue in the spaces between the clouds, in the areas where the color of the sky would be visible. With permanent green, yellow, and burnt sienna, combined in different proportions, begin to paint the mountains in the landscape.

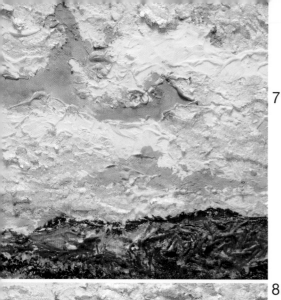

7

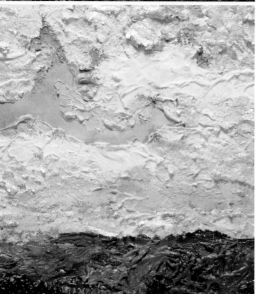

8

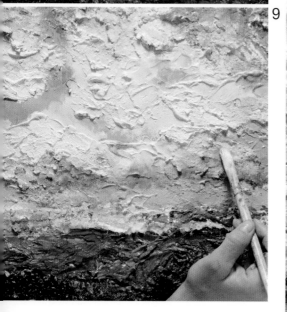

9

7 This phase of the painting is very simple and can be done very quickly. The light blue ends up defining the clouds. Different shades of permanent green, phthalo green, and emerald green cover the thick texture of rice and noodles.

8 Lighten the color of the sky near the horizon with a different lighter blue that is added to the lowest clouds. Use much thicker paint for the green parts of the landscape so it penetrates between the noodles and covers the most obvious white areas.

9 Mix burnt umber, ultramarine blue, and white to create gray, which can be used to paint the shaded lower parts of the clouds. Do not put the paint on very thick; lightly dragging the brush is enough to deposit the color on the high areas of the texture.

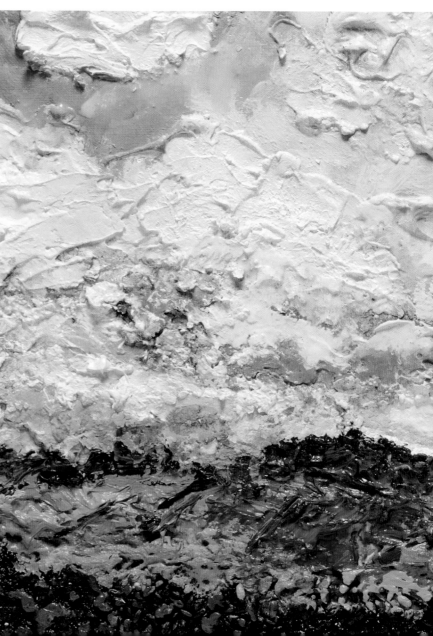

Acrylic paint should not be diluted with water. It should be opaque and creamy to be able to cover the heavy texture with a thin layer of paint.

10 To finish the landscape, apply new layers of light green and sienna. The paint should not be diluted but allowed to form peaks and enhance the texture. Brighten the upper area of the clouds with titanium white.

10

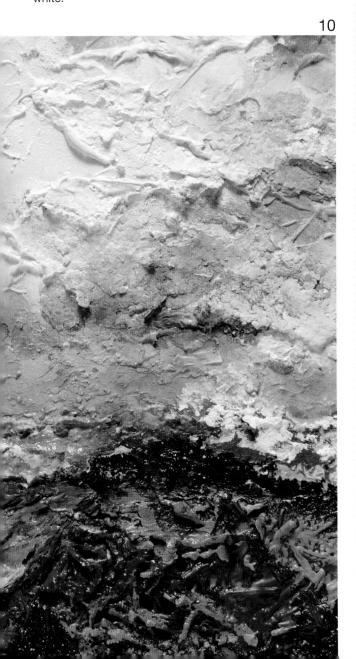

RECIPE CARD 1

DRY MATERIALS

Besides rice, noodles, lentils, and corn, any other fillers can be added to the paint to help give character to its texture. You only need to follow one important rule: organic fillers must be completely dry.

RECIPE CARD 2

SIMPLE THEMES

The themes painted over heavy textures should be very simple and should not have many details because painting thin lines and applying precise brushstrokes is difficult on this type of surface.

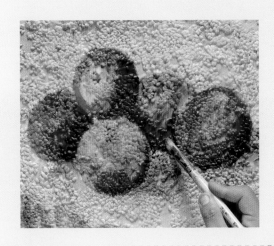

Mediums and Gels for Oils

Mediums are creamy substances that are added to acrylic or oil paints to create different consistencies and greater volume. In this section we become familiar with the different kinds of gels and mediums for oils. There are various types, each one with a different consistency and a glossy, satin, or matte finish. However, many oil mediums are simple versions of oil emulsions; therefore, it is quite safe to mix them with the paint and with each other. Here is a still life painted with oils.

The blue paint is mixed with almost the same amount of medium; even then, the intensity and brightness of the color are still visible.

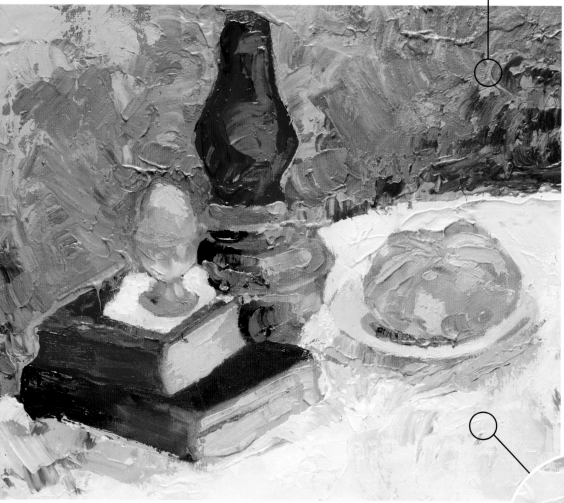

The white impasto on the tablecloth has been applied with Flemish medium, because it is the medium that changes the white color the least.

Flemish medium
allows for precise and brilliant execution with the highest degree of luminosity and transparency. It solidifies quickly and dries gradually. Used undiluted it is ideal for smooth and white supports.

Impasto medium
makes it possible to create layered impastos of up to 3/16 inch (5 mm), without cracking the paint. It is used to paint with relief, especially when using the most expensive colors because it helps conserve paint.

Oleopasto provides greater volume to the paint, but it also reduces solidity and stiffness when it is wet, giving it more of a gelatin-like consistency. It becomes more translucent as it dries.

Drying gel medium
can be mixed with paint without making it more fluid so the paint maintains its original thickness. Also, it can be added to all colors, even to the lightest ones, because it does not darken them or make them yellow.

Venetian medium is based on an old Italian recipe. This medium contains boiled oils that help impastos dry faster, makes it easier to build up paint, and its flexibility makes it ideal for painting alla prima.

The main problem of impastos, when compared with modeling paste, is their inconsistency. It usually flattens out slightly soon after it is applied because it does not contain any fillers.

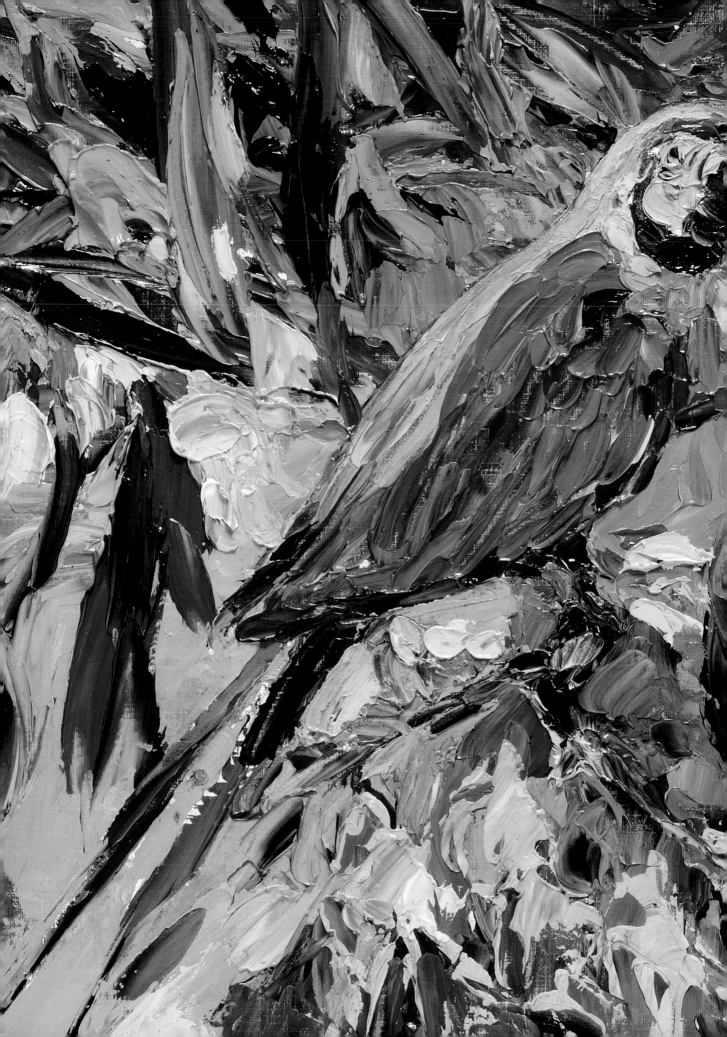

Oleopasto
with a Palette Knife

The oil impastos in this exercise stand out for their fluidity and marked textured effect. Here oil paste and paint are mixed to enhance their viscosity and volume. When the oil paint is thicker the marks left by the palette knife are more visible. Oleopasto offers another advantage: the addition of this medium to the oil mixture accelerates the drying time; therefore, the paint surfaces that would take a couple of months to dry can be ready in just a few days.

DIFFICULTY	PAINTING TIME
Medium	5 hours

INGREDIENTS

- Oil paints:
 cadmium yellow
 yellow ocher
 cyan blue
 ultramarine blue
 emerald green
 sap green
 cobalt violet
 burnt sienna
 ivory black
 titanium white.
- Oil paste

UTENSILS

- Canvas
- Round-tip palette
 knives (small and
 medium)
- Graphite pencil

Preparation

1 2 3

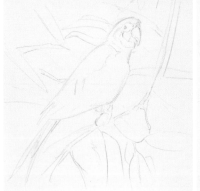
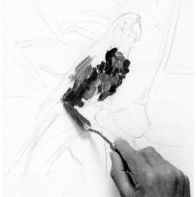
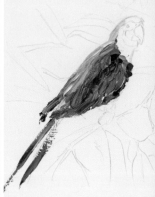

4

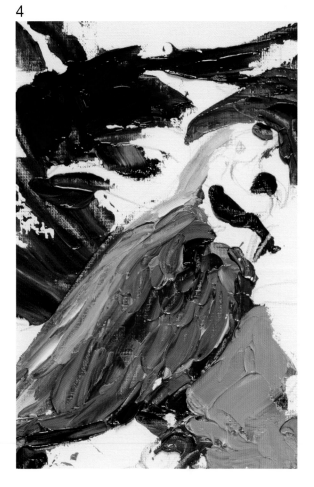

1 Make the preliminary drawing of the model with the graphite pencil. It is important to achieve the correct form and proportions so the bird can be easily identifiable. This means that this drawing will require much more attention than previous ones.

2 Mix the cyan and ultramarine blue paint with the oil paste, which will give them volume and viscosity. Pick up the paint with the back of the palette knife and apply it to the back of the bird with short strokes.

3 Dragging the palette knife in the direction of the feathers, apply shorter strokes over the wings and longer ones over the back and on the tail feathers.

4 Leave the bird and begin painting the background with a mixture of blue and green, to which you will add a small amount of ocher or white. Now, the impasto should be applied with the back of the palette knife, with wide sweeping strokes.

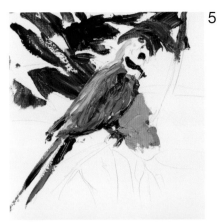

5

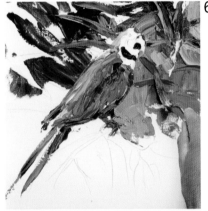

6

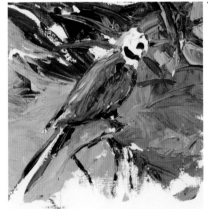

7

Advice

To clean the palette knife and change colors it is not necessary to submerge it in mineral spirits; simply remove all the paint with a paper towel or a rag.

5 Do not forget the background when painting a model. You must work on the painting as a whole so that all parts of the painting are developed at the same time.

6 Paint the tropical vegetation with long strokes. Spread the paint with the rounded tip of the palette knife extending it in the direction of the leaves.

7 Cover the lower part of the paper with ocher mixed with white and a touch of violet to give it a grayish tone. These applications should be wider and flatter, pressing with the back of the palette knife blade.

8

8 Create the branches and the leaves over the fresh ocher paint with light curving motions. Apply the paint with the tip of the palette knife with a quick flick of the wrist.

9

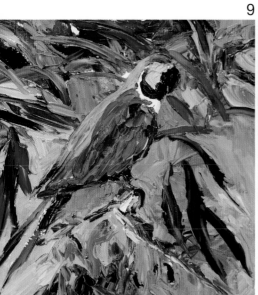

10

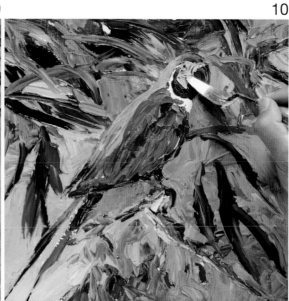

11

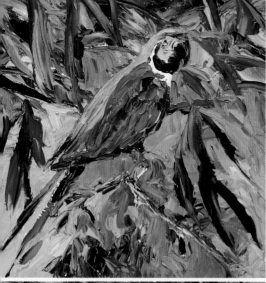

12

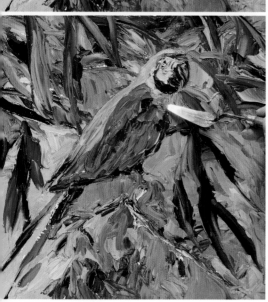

13

9 Now that the background is resolved, it is time to continue with the bird. Very carefully apply the gray, black, and white impasto to better define the head. The palette knife cannot be used for minute details, so they must be suggested.

10 The shapes of the eyes and the folds in the skin near the bird's beak are indicated by making sgraffito with the rounded tip of the palette knife, scratching the fresh gray paint.

11 Draw new leaves with quick vigorous strokes at the top of the canvas with ultramarine blue and yellow. The thick underlying paint will be dragged along the surface.

12 The dominant ranges in this work are blues and grays; now apply a contrasting yellow paint on the bird's throat. Add the color with the point of the palette knife.

Advice

If the painting requires more than one session, do not leave the oleopasto on the palette believing that it will stay as fresh as the other oil colors. It will be completely dry in a couple of days.

13 The last step consists of applying thick dabs of whitened paint in the lower part of the background, which will add more light to the composition and highlight the main element of the painting, the parrot.

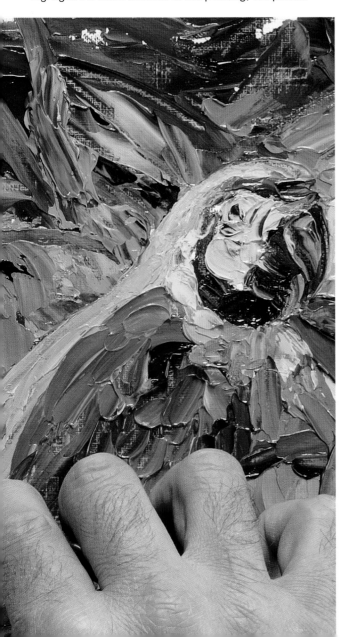

RECIPE CARD 1

INCOMPATIBLE INGREDIENTS

Do not attempt to mix oleopasto with gesso or other acrylic gel. They are incompatible ingredients. The resulting paste will be dirty and not very pretty.

RECIPE CARD 2

ADDING FILLERS TO OLEOPASTO

Later, after repeating some exercises like this one, you will be able to add a little filler to the oleopasto to create colors with a rougher texture.

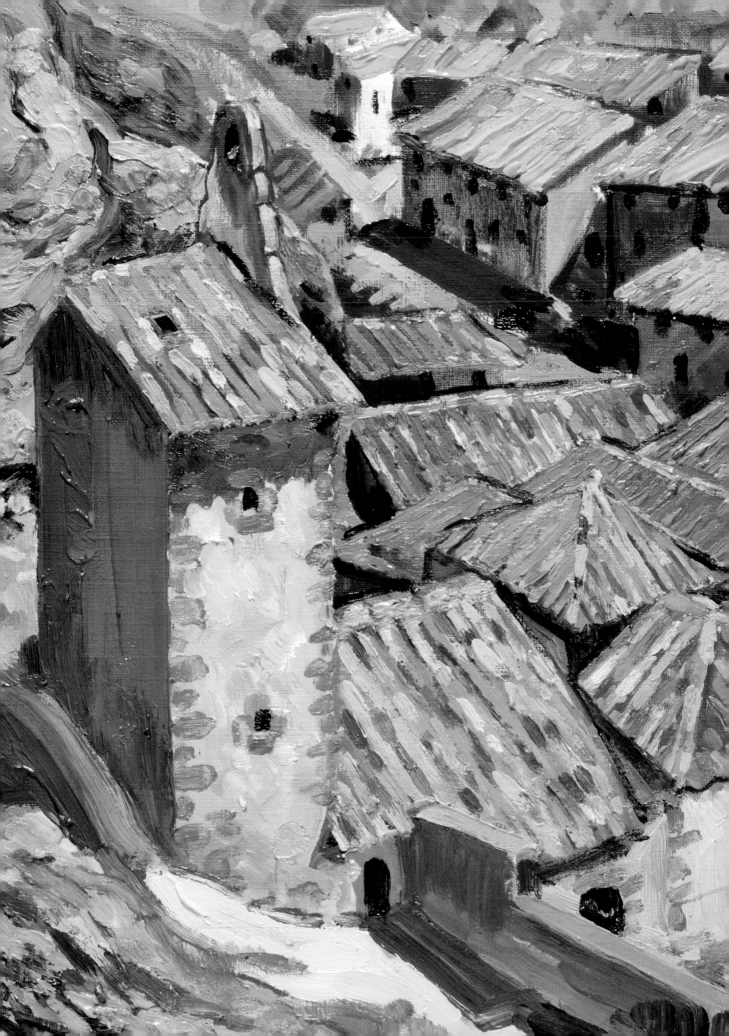

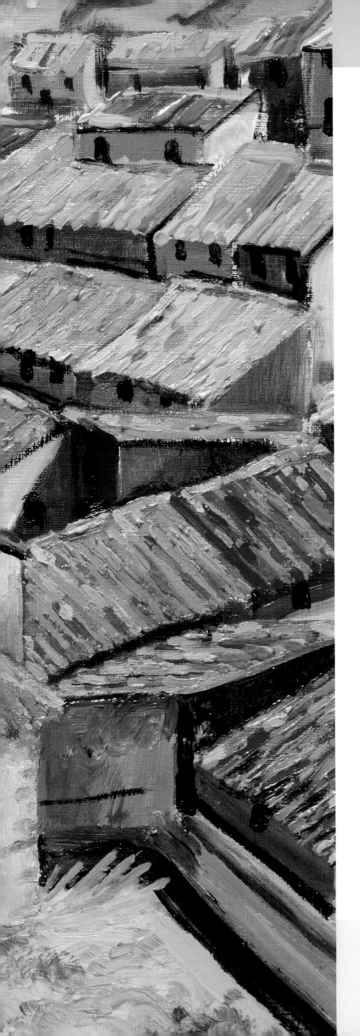

*O*il and Medium
Applied with a Brush

*T*hese rooftops in a rural landscape are ideal for creating textures. Each one of them is constructed of brushstrokes of oil paint that has been mixed with Flemish medium to give it more volume. Little by little, you deposit an amount of paint on the surface, causing small piles of paint to accumulate on each side of each brushstroke. The relief is not very heavy on the painting, but it highlights the effect of the brushstrokes and adds more energy to the colors.

DIFFICULTY	PAINTING TIME
High	8 hours

INGREDIENTS

- Oil paints:
 burnt umber
 raw sienna
 Naples yellow
 cadmium yellow
 yellow ocher
 alizarin crimson
 cadmium orange
 titanium white
 ivory black
 cadmium red
 cobalt blue
 permanent violet
- Flemish medium

UTENSILS

- Canvas
- Fine and medium filbert brushes, soft hair and hog bristle
- Fine round synthetic hair brush
- Charcoal stick

Preparation

1
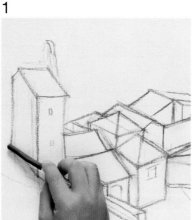

2
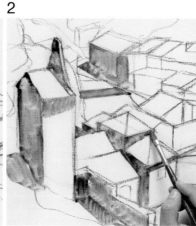

3
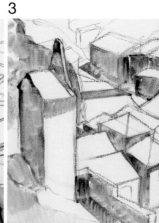

4
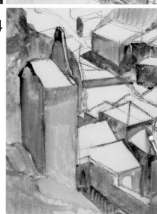

5
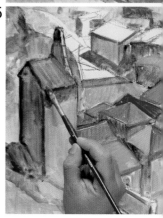

1 Draw the scene with the charcoal stick, treating each building as a simple geometric shape, in this case, as cubes and rectangular prisms. The slopes of the roofs and the walls of the houses should reflect the effects of perspective.

2 Paint the walls in shade with diluted cobalt blue and leave the more illuminated areas alone. The diluted paint also serves to fix the charcoal to the support.

3 When the blue mixes with the charcoal powder it becomes darker on the walls. This approach with the paint is similar to a watercolor. The diluted color identifies the shadows and is the first step in creating volume in the painting.

4 In this first phase of the painting, all additions of color will be diluted in turpentine. Cover the rest of the facades of the houses with lightened ocher, applying flat strokes that are not gradated.

5 Mixtures of raw sienna, yellow, and crimson will render different variations of color for painting the rooftops. Each tone should be different from the one next to it so the planes of color will stand out.

6 Finish the roofs, keeping in mind that the farthest buildings in the painting will be even more diluted and very transparent because of the way they fade in the distance.

Advice

The applications of diluted oil are best made with soft-hair brushes because they hold more paint and barely leave brush marks.

6

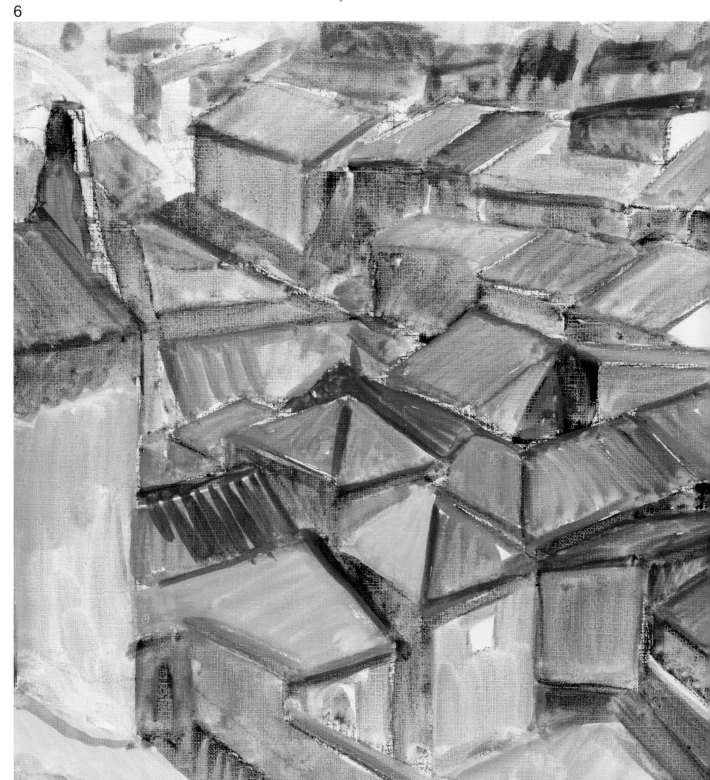

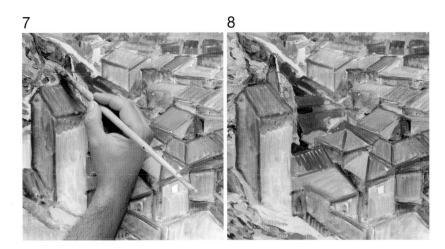

7 Now you can begin working with thicker paint. Mix some gray and brown colors on the palette with a lot of Flemish medium, which will add consistency. Apply the paint to the cliff on the left, making sure the paint builds up to form impastos with each new brushstroke.

8 Complete the rocks and the terrain to the left, at the base of the bell tower, with ocher, green, and gray tones. The grays should be very light and used to mark the light falling on the stone.

9 Paint the shaded side of the church tower with a mixture of sienna and violet. Then paint the sunny side, using gray mixed with a touch of ocher. The Flemish medium makes the paint denser and gives it a very pasty consistency.

Advice

Flemish medium can be added in small or large amounts to any color. There is no danger of damaging the paint or that it will cause cracking after it dries.

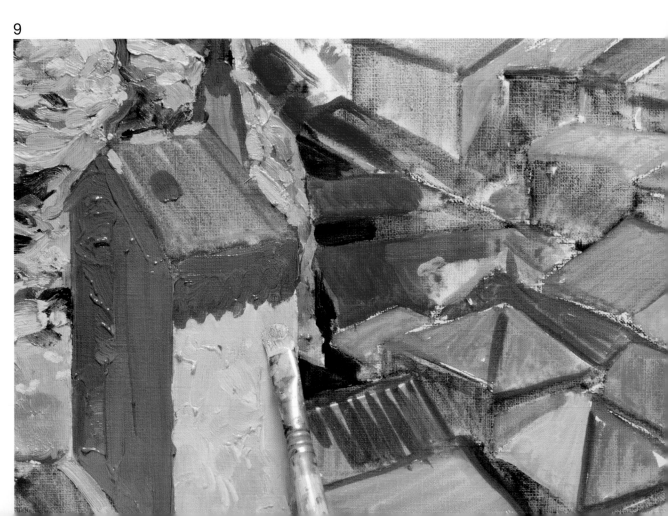

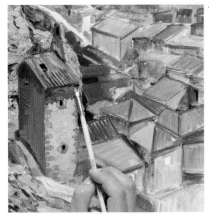

10

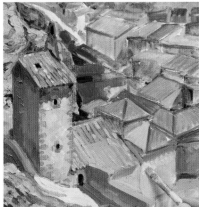

11

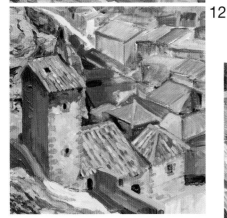

12

10 Without waiting for the paint to dry, add the architectural elements of the building. Suggest the stones with dabs of burnt umber. Then use a little black to indicate the slope of the roof and the window openings.

11 Using violet mixed with white and ocher, project the shadow of the bell tower and the wall of the lower part of the building. Then draw the diagonal lines that define the tiles on the roof with Naples yellow, ocher, and cadmium orange.

12 Paint short, alternating brushstrokes of brown, ocher, Naples yellow, and orange to create the texture of the tiles. Make sure the brushstrokes always go in the same direction. Here it is important to add quite a bit Flemish medium to make the brushstrokes stand out.

13 Use a fine round brush to paint the edges of the tiles and the more delicate areas. The synthetic hair is stiffer and can be used for impasto and to better manipulate the medium while carefully painting the shape of the belfry above the tower.

13

14

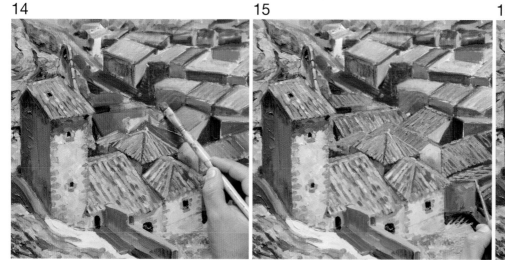

15

16

14 After the church is finished, work on the middle ground by applying thicker paint on the facades. The earlier violet colors give way to darker browns and grays that contrast with the light ocher of the sunlit areas.

15 Continue to avoid adding details to the facades of the houses. Again, build up the texture of the roofs with overlaid brushstrokes of pinks, grays, and oranges. Do not be afraid of building up impastos.

16 The elements of the scene will be less defined as they move toward the background. This means that you should not spend much time painting those roofs. You only need to make a few strips of different tones on the slanted rooftops.

17 Mix burnt umber and ivory black for the final touches. It is now a matter of carefully painting the dark bases of the eaves and the openings in the facades. It is not a matter of creating details; simple dark strokes are sufficient.

17

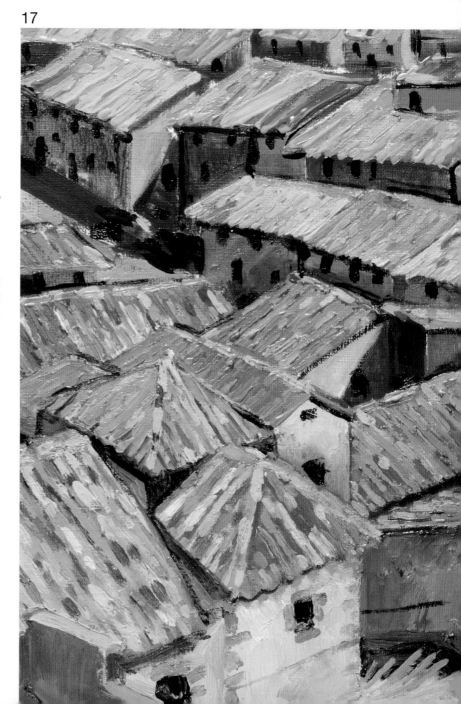

RECIPE CARD 1

EXPERIMENTING WITH MEDIUM

Before beginning to paint with any medium, whether you are working with impasto or Flemish or Venetian mediums, it is a good idea to become familiar with them, learning to mix them with the paint barely adding any turpentine, which reduces the consistency.

RECIPE CARD 2

MORE GEL MORE TRANSPARENCY

You can add 3/4 parts medium and 1/4 part oil paint. The medium helps you economize and stretch your paint. Using a greater amount in each mixture can produce transparent impastos.

RECIPE CARD 3

BRUSHING LIGHTLY

To leave heavier brush marks of paint and medium you should hold the brush at a steep angle and barely apply any pressure, softly caressing the painting.

RECIPE CARD 4

FINISHES WITH MEDIUM

When the painting is finished and the surface is dry, you can still paint with medium alone and apply impastos that are more or less transparent that will increase the relief.

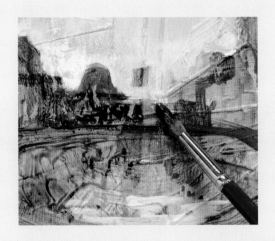

Suggestions

Glazes with Body

Using different mediums like wax gel or heavy gel with a latex or acrylic base, it is possible to create thick textures that can be translucent at the same time, like color glazes that modify the colors that are underneath. Mixing a very small amount of acrylic paint and thick gel, or oil and wax gel, you can create a thick substance that can be used for glazes and impastos, which can be applied with a brush or palette knife. This new type of texture can change the look or change the value of the colors, depending on its intensity and the amount of light in the painting. This landscape was done in oil.

Each oil color was first mixed with wax gel on the palette. The wax adds a creamy look to the surface.

Wax gel can be applied directly to the canvas without mixing it with paint, to make a whitish impasto, for example, which will act as a glaze.

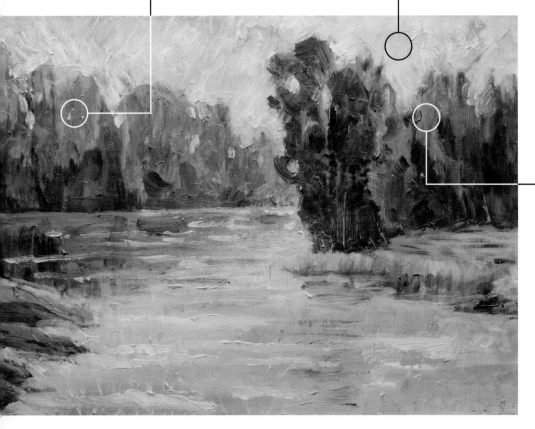

Wax gel is white in color, but it becomes somewhat transparent when it is applied in thin layers.

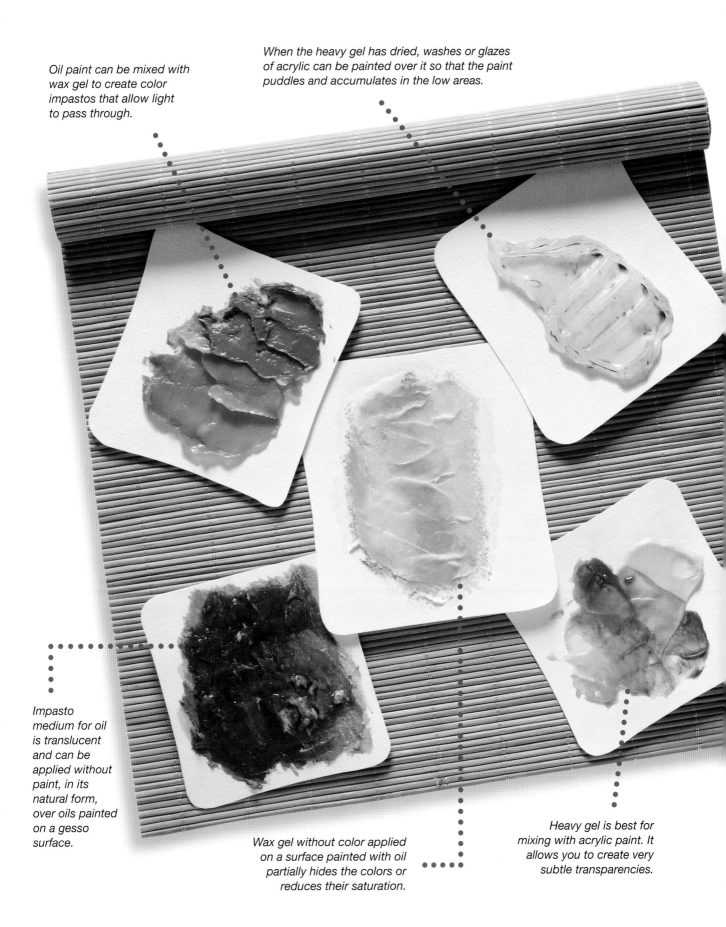

Oil paint can be mixed with wax gel to create color impastos that allow light to pass through.

When the heavy gel has dried, washes or glazes of acrylic can be painted over it so that the paint puddles and accumulates in the low areas.

Impasto medium for oil is translucent and can be applied without paint, in its natural form, over oils painted on a gesso surface.

Wax gel without color applied on a surface painted with oil partially hides the colors or reduces their saturation.

Heavy gel is best for mixing with acrylic paint. It allows you to create very subtle transparencies.

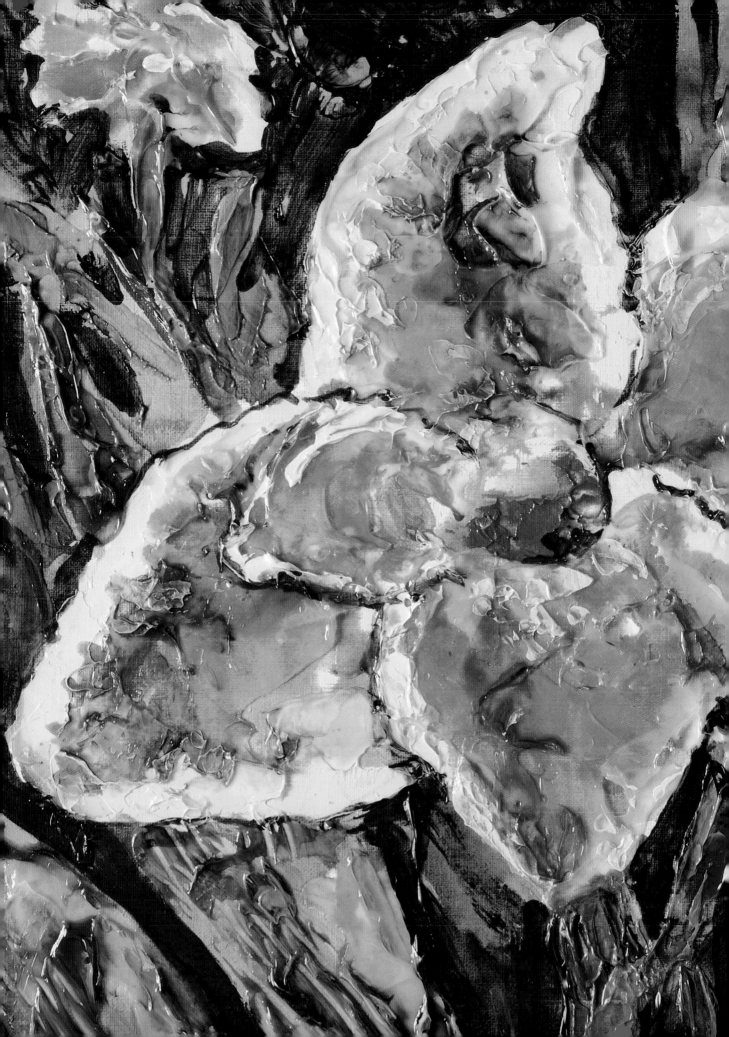

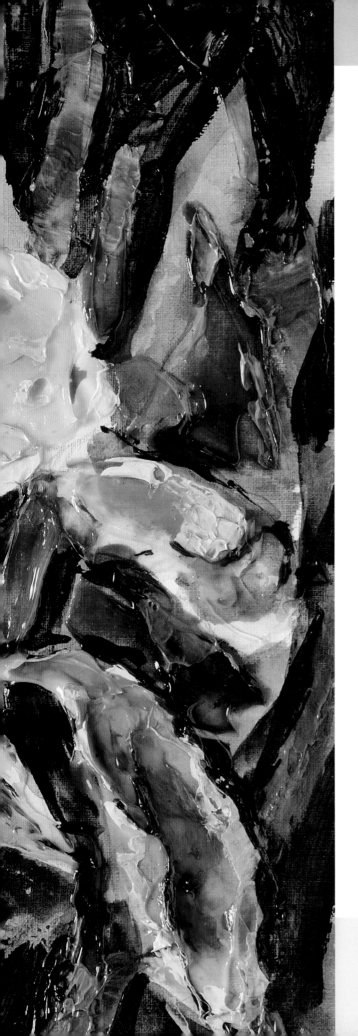

Impasto
with
Transparencies

A small amount of acrylic paint mixed with a large amount of thick gel can be used to paint glazes with texture, that is, impastos with light tints of color that become translucent when dry and allow the colors underneath to show through. This means that some models can be constructed by superimposing thick and smooth glazes, to which can be added modeling effects and lines made with a palette knife. The working process is very slow and requires prolonged drying times between steps, but the result is worth it.

DIFFICULTY	PAINTING TIME
High	48 hours

INGREDIENTS

- Acrylic paint:
 titanium white
 cadmium yellow
 yellow ocher
 naphthol red
 quinachridone pink
 cyan blue
 permanent green
 phthalo green
 burnt umber
 ivory black
- Heavy gel

UTENSILS

- Canvas
- Metal palette knife
- Medium round
 brush with soft hair
- Graphite pencil
- Fork

Preparation

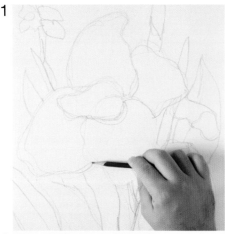

1

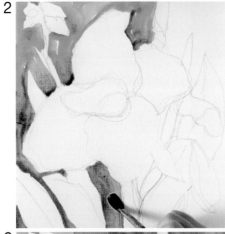

2

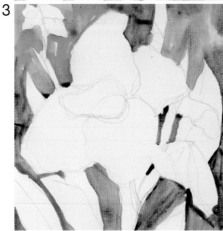

3

1 Draw the model with a continuous line, using the side of the graphite point of the pencil. Make free and loose movements of the hand while barely lifting the pencil from the paper, tying one line to another as if it were a continuous thread.

2 Use the brush to paint the background, the space surrounding the flower, with a wash of permanent green acrylic at the top of the canvas and the same color mixed with black at the bottom of the canvas.

3 Mix the green and black to form gradations in the center area of the painting. By painting the background first the main element of the painting is clearly outlined. Wait a few minutes for the background to completely dry before painting the inside of the flower.

Advice

Whenever you work with oil or acrylic washes, always use soft-hair brushes. They are able to hold a larger amount of diluted paint.

4

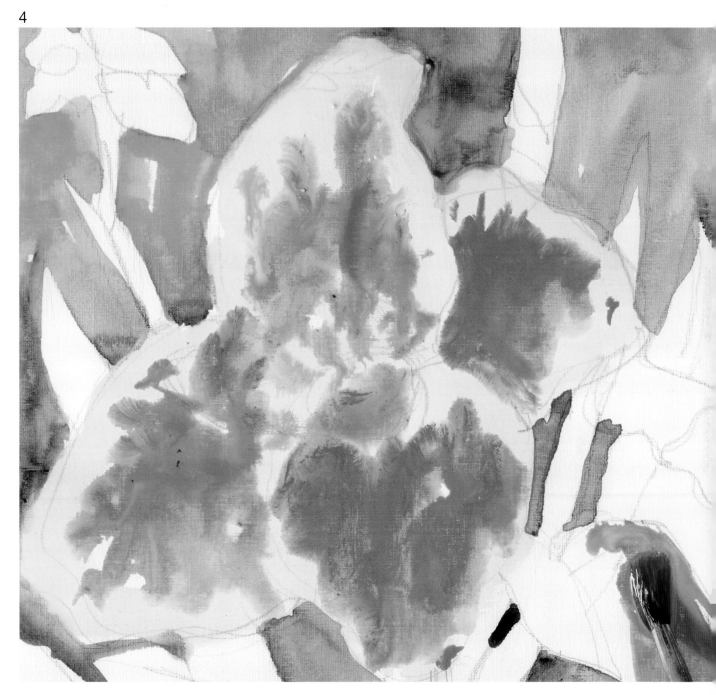

4 Charge the brush with very diluted cadmium yellow and red, and apply them to the petals of the flower. This will cause accidental mixtures and blending between the two colors that will imitate the typical coloring of this kind of flower.

Advice

When you apply heavy gel that is lightly tinted with acrylic paint, it will look white at first. The transparent effect will become visible when the gel dries, but not before.

5

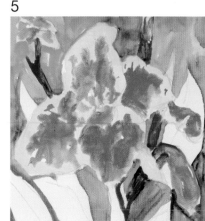

6

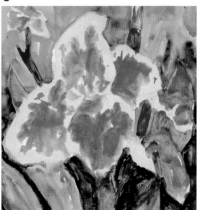

7

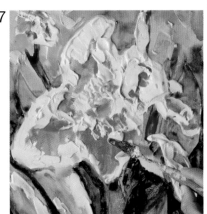

8

5 After the flowers are painted, work down the surface of the canvas, painting the stems with the same red used on the petals, but now mixing it with green. Here the work is more delicate; use only the tip of the brush.

6 Make a turquoise color by adding a dab of cyan blue to permanent green. Then use this color to paint the lower leaves. After it dries, the background color is not as intense, so reinforce it by adding some diluted black. The painting should then be allowed to dry for one hour.

7 Begin applying translucent impastos with the palette knife over the dry paint. To create impasto glazes with heavy gel, mix very little color with a large amount of gel. Mix the paste well with the palette knife and apply it to the center of the painting.

8 Tint the heavy gel with permanent green. The amount of paint you use should be minimal, almost nothing. Apply it to the leaves with the palette knife, and texture it by dragging a fork through the impasto.

9 After the first impastos are added the model looks very white and milky. This is because the acrylic component of the gel has not dried. It is a good idea to stop now and let the painting dry for a whole day.

9

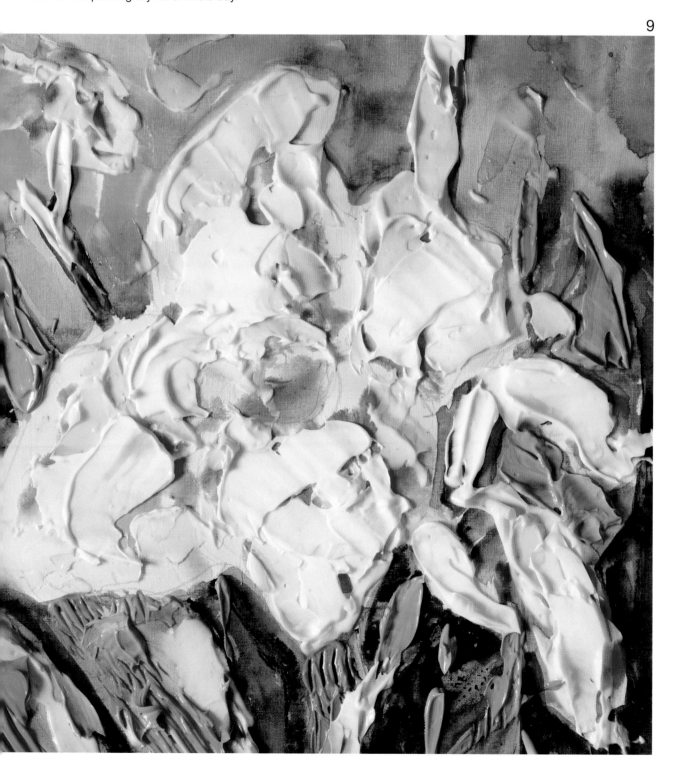

10 **11** **12**

 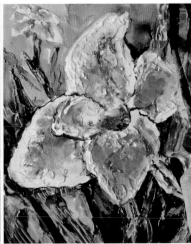

10 The gel has become completely transparent and formed a glaze over the previous washes. Go back to work with the palette knife and add more yellowish and pinkish impastos over the others.

11 Use a lighter green to add new shades to the leaves and stems, differentiating the areas of light and shadow. Then add some more paint to the flower petals to make more shades that are not as contrasting, but more limited.

12 After the plants are resolved with impastos of heavy gel, darken the background with thick ivory black paint.

13 After the painting is finished you only have to wait another twenty-four hours for the heavy gel impastos that you just applied to lose their opacity and become transparent.

Suggestions

RECIPE CARD 1	RECIPE CARD 2
AROUND EACH BRUSHSTROKE	**GLAZES WITH GEL**

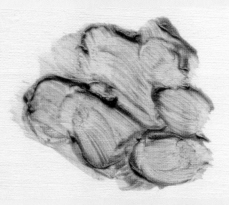

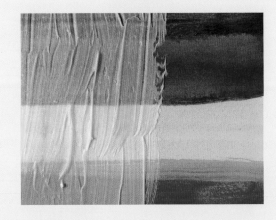

When you use a brush to apply transparent impastos, the paint tends to accumulate around each brushstroke, leaving a thin layer of streaked translucent color in the center of each mark.

Some gels are not completely transparent. They form a whitish layer of color that acts as a glaze over any color surface. It is a good idea to experiment with them first on a colored background so there will be no surprises when painting.

13

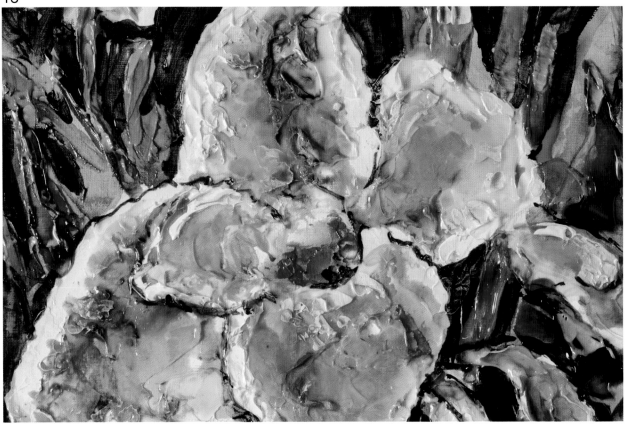

RECIPE CARD 3

CRACKLING
THE SURFACE

You can lightly press a gel and paint-covered surface with paper while they are still wet. Pull it away carefully to make a uniformly crackled surface.

RECIPE CARD 4

SURFACE
WITH BRUSHSTROKES

If you leave the brush marks in the impasto, after the gel dries it becomes transparent and they will disappear. However, if you apply a color glaze to the whole surface, they will stand out more strongly.

Wash over Gesso

When you apply a color wash or diluted paint over surfaces textured with gesso or modeling paste, the paint tends to enhance and highlight the main areas of the surface relief. On the other hand, when you apply glazes, either acrylic or oil, the diluted paint usually settles and fills the nooks and crannies, forming small puddles, which when they dry will highlight the gaps and hollow areas that contrast with the raised parts, which will be of a lighter color. This exercise was painted with acrylics.

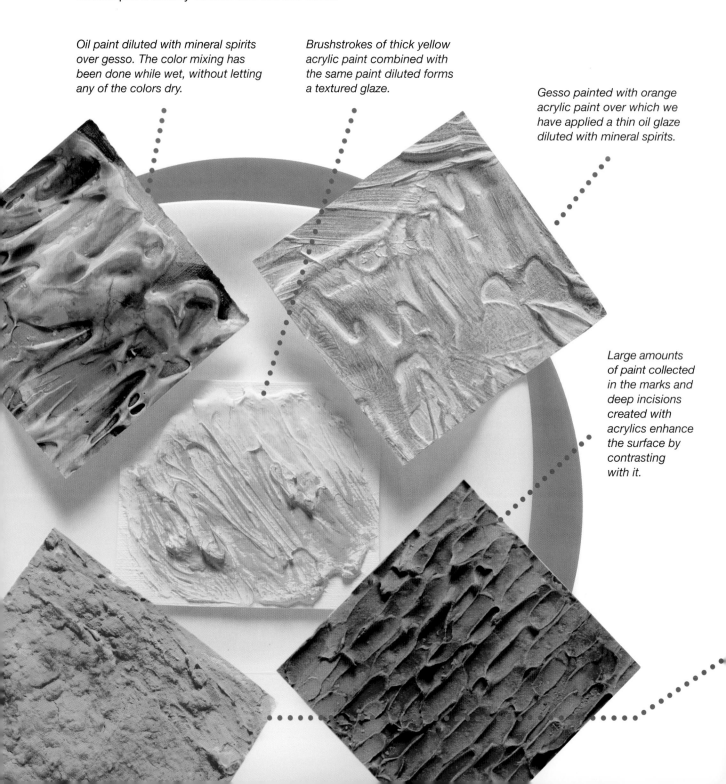

Oil paint diluted with mineral spirits over gesso. The color mixing has been done while wet, without letting any of the colors dry.

Brushstrokes of thick yellow acrylic paint combined with the same paint diluted forms a textured glaze.

Gesso painted with orange acrylic paint over which we have applied a thin oil glaze diluted with mineral spirits.

Large amounts of paint collected in the marks and deep incisions created with acrylics enhance the surface by contrasting with it.

Grooves or lines created with sgraffito using the round tip of a metal palette knife.

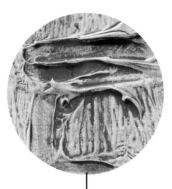

When looking at the surface close up, we can see that the diluted paint collected in all the cracks and indentations highlights the texture.

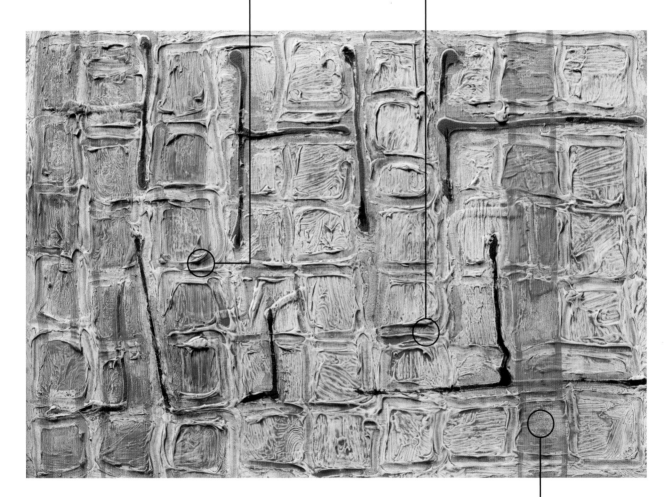

You can add Spanish white or a small amount of powdered plaster to the gesso to make it more porous and for the oil paint glaze to produce softer tonal transitions.

To apply a second layer of paint, in this case orange over a blue wash, it is a good idea to wait for the paint mixed with mineral spirits below to dry.

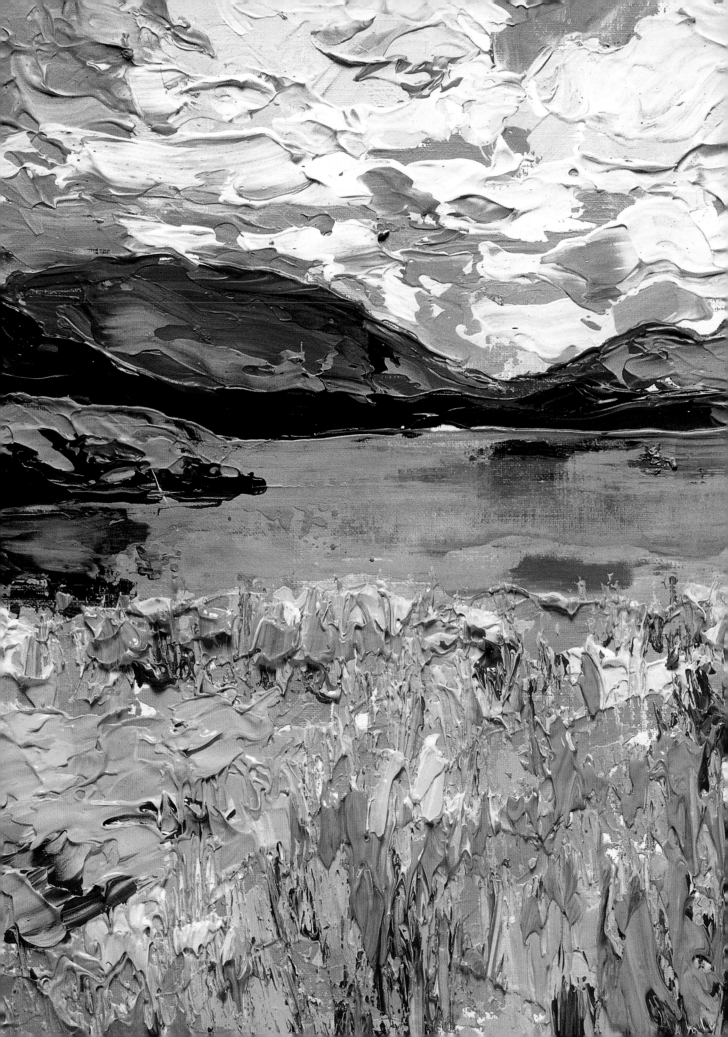

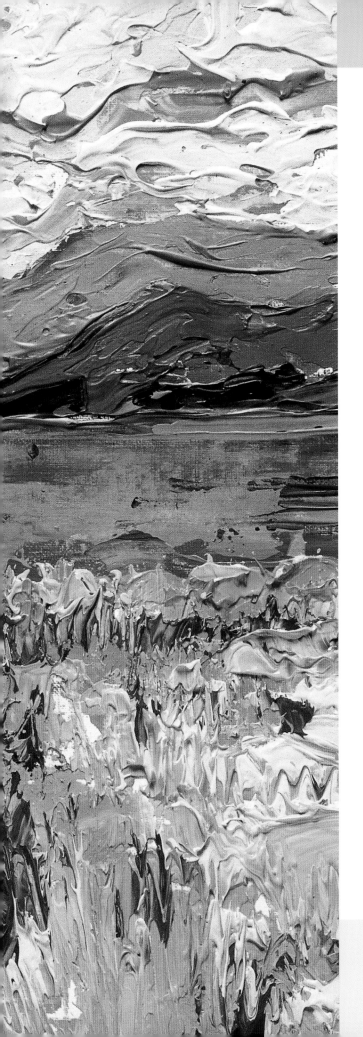

Landscape
with Acrylic and Gesso

Gesso mixed with acrylics provides greater consistency and volume to the paint, the same way that oleopasto and oil paints do, with the difference that the finish is more matte and the colors look lighter and more luminous. The fast drying time of acrylics and gesso makes it possible to superimpose several layers of paint until the desired volume is achieved.

DIFFICULTY	PAINTING TIME
Medium	3 hours

INGREDIENTS

- Acrylic paints:
 burnt umber
 phthalo red
 phthalo green
 ultramarine blue
 lemon yellow
 yellow ocher
 permanent violet
- White gesso

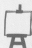

UTENSILS

- Canvas
- Medium flat metal
 palette knife
- 2B graphite pencil

Preparation

1 Draw the main forms of the landscape by pressing very gently on the lines with the 2B graphite pencil. It is not necessary to make a very precise drawing; a rough layout is sufficient.

2 Mix the acrylic paints and the gesso on the palette. Pick up the paint with the blade of the palette knife and apply it to the sky with variations of gray-violet. Drag the palette knife flat, pressing it against the canvas.

3 Add more gesso to the colors of the sky to give it greater volume. If the previous paint layer is dry, you can apply a new layer over it. For the clouds, alternate pinks, violets, and gesso, which will produce the white color. Use ultramarine blue and gray to paint the outlines of the mountains in the distance. Be careful not to manipulate the gesso too much, or the colors will end up mixing together.

1

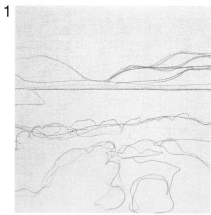

2

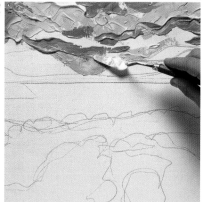

3

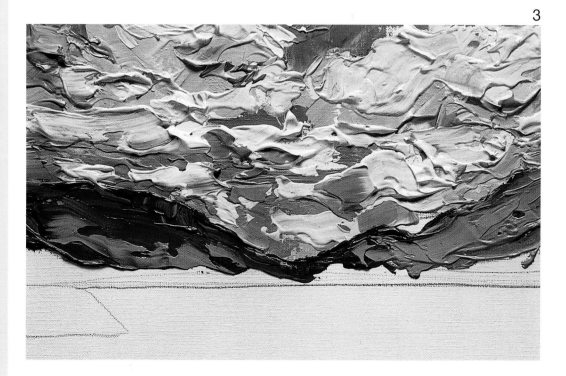

4 The mountains that are closest to the lake should be darker than the ones in the background. The different planes must be coherent with the fading of color that occurs with distance.

5 Fill the area of the lake with ultramarine blue mixed with the same gray that was used for the sky. Work from side to side horizontally with the palette knife held flat against the canvas, to create a smooth surface without any impasto marks.

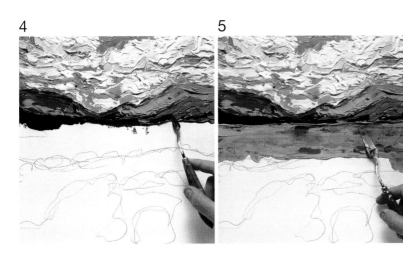

4 5

6 Mix yellow with a touch of red to make orange to cover part of the area in the foreground. The colors for the vegetation will be applied later over this base.

6

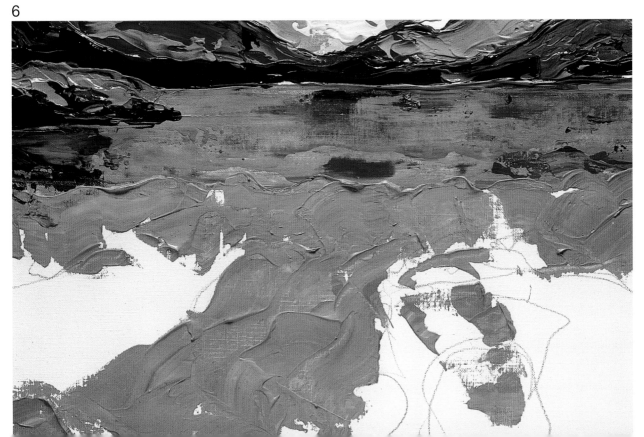

7

8

9

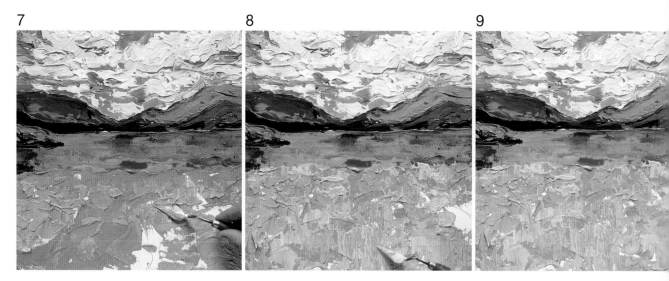

7 The orange paint dries in only a few minutes and now a second color can be applied, this time light green, adding yellow immediately after allowing both colors to blend together.

8 Continue working the vegetation with new yellow paint, which is applied by alternating the tip of the palette knife with the side of the blade, dragging the paint vertically at all times.

9 The superimposed colors in the foreground begin to look like a mass of varied and diverse vegetation rather than appearing with too much detail.

10 To finish, scratch lines over the surface of the fresh layer of paint with the tip of the spatula and add new burnt sienna paint in the darker areas of the field.

10

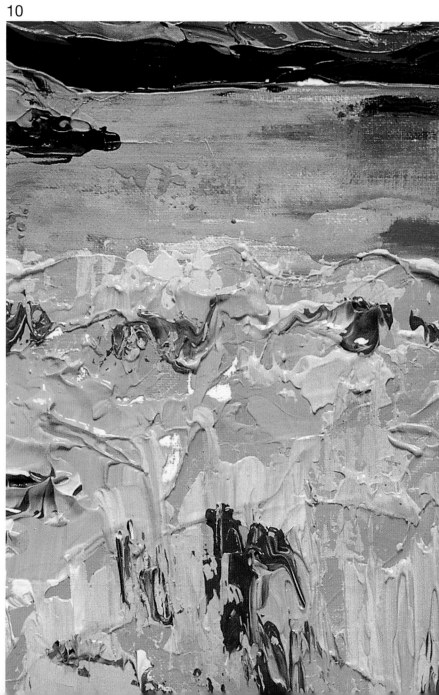

Advice

It is a good idea to add more gesso to the paint for the vegetation in the foreground to make it thicker so it appears to be closer.

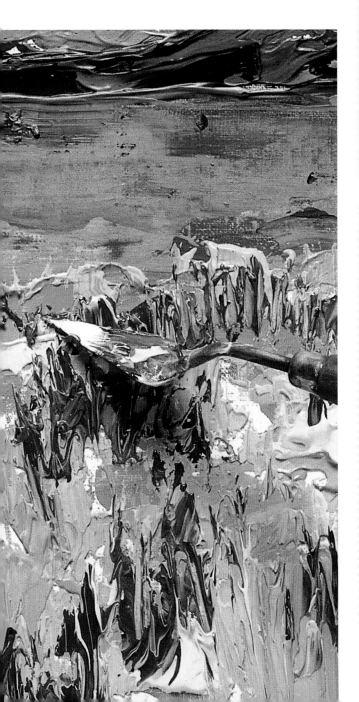

RECIPE CARD 1

STRIATED MIXTURE

When the gesso and acrylic paint are blended together unevenly on the palette, the resulting combination looks striated. This mixture can be used to paint the lines and forms of the vegetation.

RECIPE CARD 2

SMOOTH AND THICK GESSO

The key to obtaining good results is to use gesso generously, forming a thick layer of color that mixes with the acrylic paint. Even if the painting lacks definition, it will gain in expressivity.

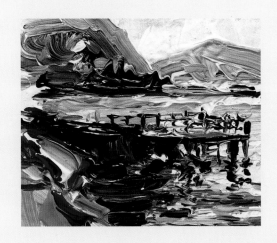

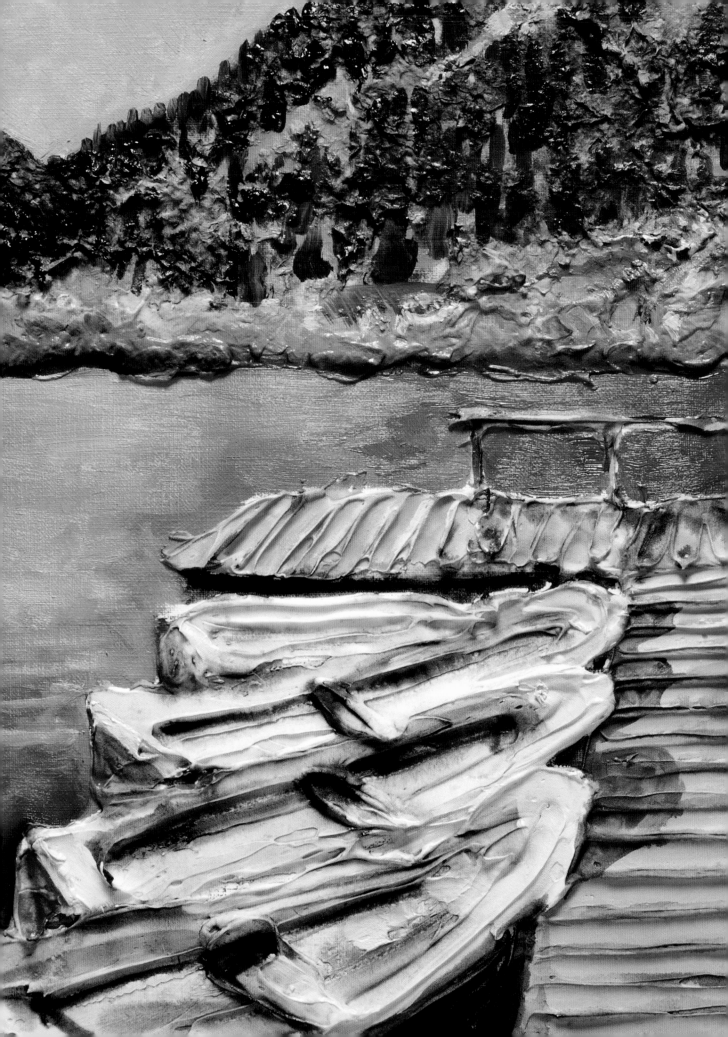

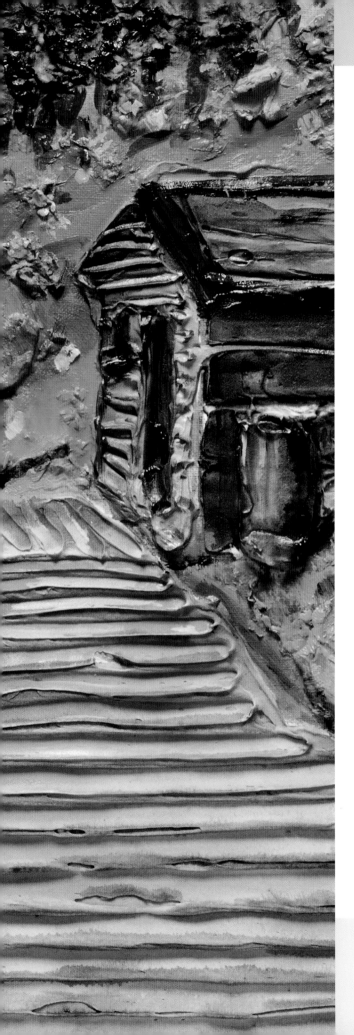

Wash
over Gesso and Paper Paste

*T*he relief of this painting's surface has been created with gesso and paper paste, modeling every texture with the palette knife, from the wood planks of the dock to the lush vegetation in the background. When it dried we painted over it with oils mixed with mineral spirits, creating an interesting relationship between paint and texture, in such a way that it is difficult to say where one begins and the other ends. For the last touches we used thicker oil paints that highlight the areas with the brighter colors.

DIFFICULTY	PAINTING TIME
High	40 hours

INGREDIENTS

- Oil paints:
 burnt umber
 cyan blue
 ultramarine blue
 permanent green
 compound green
 sap green
 titanium white
 yellow ocher
 cadmium yellow
 ivory black
 burnt sienna
- Latex
- Newspaper
- Gesso or thick
 modeling paste

UTENSILS

- Canvas
- Metal palette knife
- Soft-hair medium
 round brush
- Medium flat filbert
 brush
- Graphite stick

Preparation

1 Draw the dock and the boathouse with the graphite stick. The rest of the landscape can be drawn with a few spontaneous lines, going back to the main lines, which are reinforced with the tip of the lead stick held at an angle.

2 Before applying the paint prepare the paper paste by mixing small pieces of newsprint and latex in a bottle. Let the paper with the glue rest for a day and then apply the paste over the upper area of the support.

3 Continue working the surface with modeling paste and gesso. Spread the paste with a palette knife, modeling the wood boards of the dock and the boathouse with the round tip.

4 Apply a generous layer of gesso about 1/8 inch (4 mm) thick and define it and model it with the palette knife. Spread it with the palette knife gently, caressing the layer of white paste.

1

2

3

4

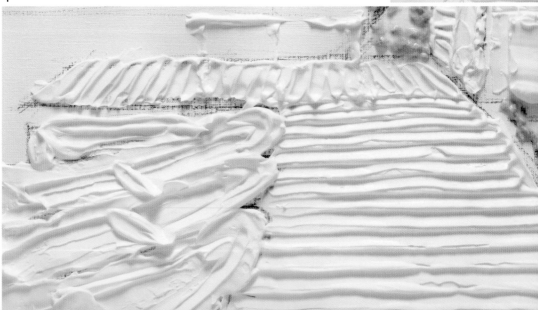

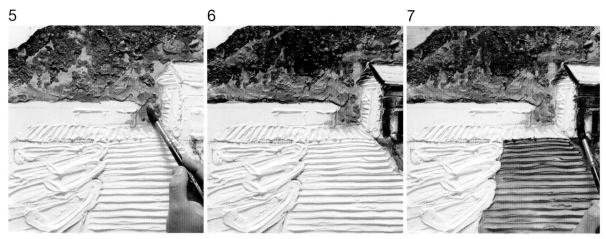

5 6 7

8

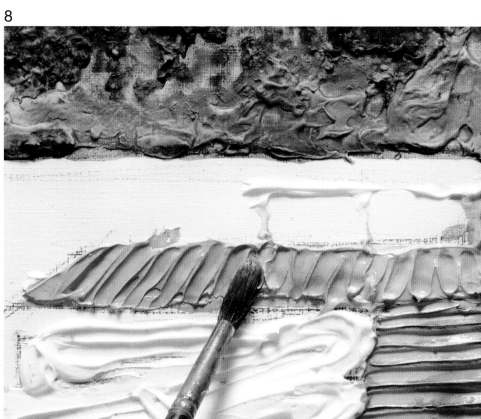

5 Wait a day until the gesso has dried completely before you begin to paint. Cover the upper part with different green colors mixed with mineral spirits. The diluted color settles in the cracks and enhances the relief effect.

6 Oil paints work as if they were glazes; therefore, the luminosity of the color does not depend on the amount of white added to the mixture but to the dilution with the mineral spirits.

7 Paint the wood dock with burnt umber and a small amount of black. Both colors will blend together forming soft gradations, without any sudden changes. Paint the shaded area of the boathouse with medium gray.

8 Finish the dock with ocher mixed with white. Apply more gray over the ocher wash, while still wet, so both colors blend together. Soft brushes are the best for working with diluted paint, given their high level of absorption.

Advice

Except for the lake, it is important not to make the areas too smooth. The gesso should have a lot of texture with repeated marks, cracks, and hollow areas.

9 Break up the white color of the boats with an ocher color similar to the one used on the dock, although much more diluted. After a few minutes, when some of the mineral spirits have evaporated, apply several blue brushstrokes over them and paint the shadows projected by the boats over the wood boards on the dock with a dark brown.

10 Wait a few minutes before applying a wash over the previous one. Then, finish the boathouse with neutral gray for the front and blue for the roof. Paint the door and the window with green darkened with black. The wood veranda is painted with ocher lightened with white.

11 Paint the lake with the filbert brush and thick, undiluted paint, combining the ultramarine and cyan blues. Add a small amount of dark green in the shaded areas.

12 With a mixture of cadmium yellow and green, lighten the green of the vegetation of the side of the hill. Apply heavy brushstrokes so the paint stays on the texture's raised areas. The contrast of the boathouse, painted with a more luminous green, helps define the surrounding areas.

9

10

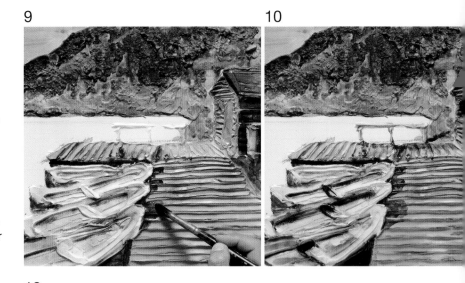

12

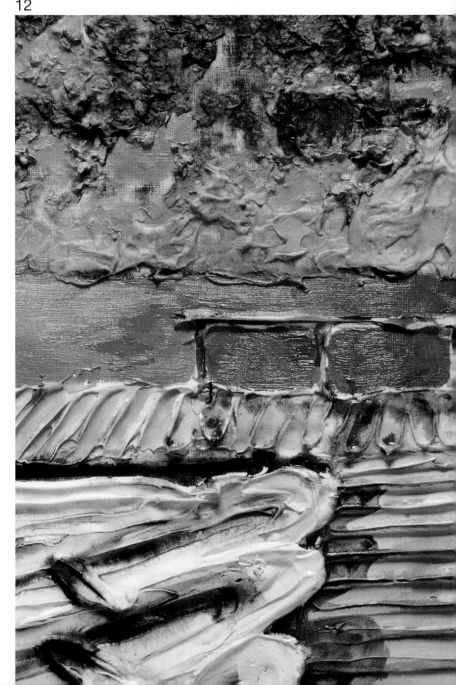

Advice

As the oil paint mixed with mineral spirits dries the colors lose their glossiness and turn a little bit lighter. For this reason more intense colors should be used.

11

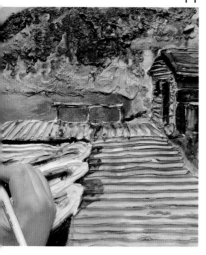

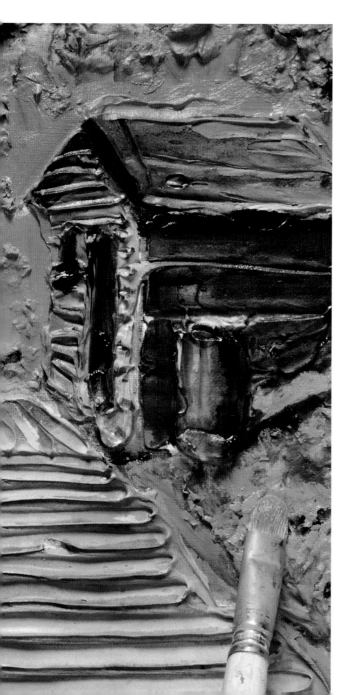

RECIPE CARD 1

WORKING
THE SURFACE

The gesso is not simply applied to the surface but it has to be worked by drawing, modeling, and, if needed, sculpting marks and lines that will be enhanced later when they are painted over with diluted paint.

RECIPE CARD 2

CHECKING THE
MODELING WORK

To make sure that the modeling with gesso is correct, simply apply a wash evenly over the entire surface. If the forms of the model can be distinguished clearly, it means that the work is good.

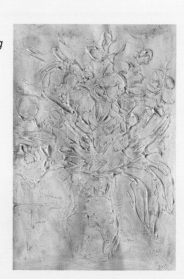

Suggestions

First edition for the United States, Canada, and its territories and possessions published by Barron's Educational Series, Inc.

English language translation © Copyright 2011 by Barron's Educational Series, Inc.

Original title of the book in Spanish: *Recetas para pintar texturas*
© Copyright 2011 ParramonPaidotribo—World Rights
Published by Parramon Paidotribo, S.L., Badalona, Spain

Design and Production: Parramón ediciones, S.A.
Editor In Chief: María Fernanda Canal
Editor: Mª Carmen Ramos
Texts: Gabriel Martín Roig
Exercises: Gabriel Martín, Óscar Sanchís, and Gloria Valls
Collection Design: Josep Guasch
Layout And Design: Estudi Guasch, S.L.
Photography: Nos & Soto
Production: Sagrafic, S.L.
Prepress: Pacmer, S.A.

English Translation: Michael Brunelle and Beatriz Cortabarria

All inquiries should be addressed to:
Barron's Educational Series, Inc.
250 Wireless Boulevard
Hauppauge, New York 11788
www.barronseduc.com

ISBN-13: 978-0-7641-6496-5

Library of Congress Catalog Card No. 2011936771

Printed in China
9 8 7 6 5 4 3 2 1

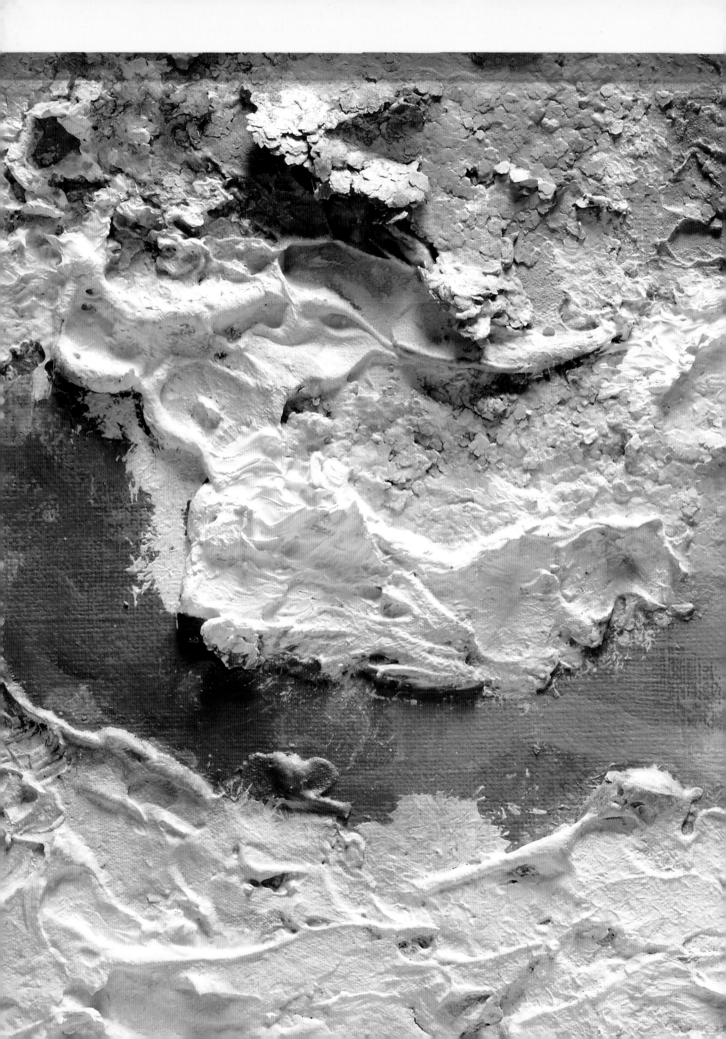